HOW TO PAINT & $ELL YOUR ART

Marcia Muth

Sunstone Press
Santa Fe, New Mexico

*Dedicated in appreciation to
Aunt Doris Bernhardt,
the first artist I knew,
and to
my friend and my agent
Yolanda Saul.*

Copyright © 1984 by Marcia Muth
All Rights Reserved. No part of this book may be reproduced in any form or by any electronic or mechanical means including information storage and retrieval systems without permission in writing from the publisher, except by a reviewer who may quote brief passages in a review.

FIRST EDITION

Library of Congress Cataloging in Publication Data:
Muth, Marcia, 1919-
 How to paint and sell your art.

 Bibliography: p. 70
 Includes index.
 1. Painting—Technique. 2. Painting—Marketing. I. Title. II. Title: How to paint and sell your art.
ND1500.M87 1983 750'.68 83-18252
ISBN: 0-86534-019-6

Published in 1984 by Sunstone Press / Post Office Box 2321 / Santa Fe, New Mexico 87504-2321 / USA

TABLE OF CONTENTS

FOREWORD / 5

I / "I DON'T HAVE ANY PLACE TO PAINT!" / 6

II / "DON'T JIGGLE THE TABLE" / 10

III / THE DELIGHTS OF DRAWING / 14

IV / THE FIRST STROKE IS THE HARDEST! / 18

V / SPONTANEITY PLUS SPARKLE / 23

VI / SUBJECT & STYLE OR "I KNEW THAT WAS YOURS" / 25

VII / LOOK IT UP OR LEAVE IT OUT / 27

VIII / "WHICH BUTTON DO I PUSH?" / 32

IX / SEVEN O'CLOCK SCHOLAR / 36

X / THERE IS SAFETY (& SOLACE) IN NUMBERS / 39

XI / "I CAN DO *THAT*" / 42

XII / THE PUBLIC EYE AND THE PRIVATE ARTIST / 44

XIII / SHOW & TELL / 46

XIV / IF THE PRICE IS RIGHT / 51

XV / FOR BETTER OR WORSE / 55

XVI / SATISFYING YOUR EGO & THE I.R.S. / 60

XVII / MAKING IT LEGALLY YOURS / 64

XVIII / TEN TIMELY TIPS / 66

XIX / TERMS TO TOSS AROUND / 68

BIBLIOGRAPHY / 70

LIST OF ASSOCIATIONS / 72

AFTERWORD / 75

INDEX / 76

FOREWORD

I have written what I hope is a practical and very useful book. It is based on my own working experiences and experimentation in art. It has the answers to some of the questions I asked when I first started to draw and paint. The main point I want to make, however, is that the most important thing you can learn is to go ahead and do *your* art. Try out your ideas, test your techniques and *never* give up.

I
"I DON'T HAVE ANY PLACE TO PAINT!"

"I'm really interested in art and I want to try out some of my ideas but I don't have any place to paint!" complained Anita T.

She didn't realize it but that is one of the most common reasons people give for not starting to paint. Sometimes the comment is delivered in plaintive tones; sometimes aggressively, almost challengingly.

I must confess that when I started to paint, the question of "where" loomed pretty large in my mind but perhaps we have all been spoiled by seeing pictures of well-known artists' studios in books and magazine articles. We tend to forget that these studios usually show the artists at the zenith of their careers. Few artists start out with a big, fully equipped studio. And it is well to remember that it is not the studio that makes the artist, but the other way around.

The size of your studio will depend upon the space available and your own artistic needs. I started in a corner of the kitchen, later took over part of the guest bedroom and eventually ended up using the entire family room as my studio. I still have plans for a studio especially designed for my purposes but that is in the future. I do find that I know a lot more now about what I want and need in a studio and, from practical experience, I knew the most convenient way to arrange my equipment and supplies.

Sometimes it is possible to convert an extra bedroom to a studio. By replacing the bed with a studio couch, you can still have a guest room but you have acquired more space. Add some shelves for supplies, books and magazines. Most discount stores sell metal utility shelves that are good for studio use and they are less expensive than wooden ones. You may also want to protect the floor. I have always found it necessary to add lights. The ones I like are fluorescent shop lights which can be hung from chains in the ceiling and be adjusted to the height you find most desirable. They are also easy to take down if you move to another location. They can be purchased in hardware stores, discount stores, etc. If the walls are plaster, a picture molding strip can be added so you can hang your pictures more easily. If there is a closet in the room, that is the place to store canvases, extra easels and other large items.

The greatest advantage to having a separate room as a studio is, of

course, that all your things are in one place and are easily accessible. You can leave your work and go back to it whenever you can. With everything set up at all times, you don't lose any time getting down to painting. And, if your household includes small children or inquisitive pets, you will be thankful you can shut the door to your studio. It is very upsetting to come back into your studio and find the cat sleeping on your charcoal drawing or a young member of the family, as a friend of mine found, adding some color to "mommy's picture." If you are sensitive about people seeing your work, the shut door can keep the curious out.

One of the disadvantages is in keeping it just a studio. It took one artist I know several months to train her family not to use her small studio as a catch-all for their boots, skiis and skates. If this is a problem you may face, find another place for the boots, etc., and let it be known that that is where they should be kept. Take yourself and your art seriously.

If you have a lot of overnight guests, you may not find it practical to combine a guest room with a studio. Invariably, just as you are making progress on a picture, you will have to give up and admit a guest who will use your easel as a convenient hanger.

It may take several weeks for you to decide how to best arrange your studio. Don't be in a hurry and don't be afraid to make changes if you don't feel comfortable with your first arrangement. Experiment with the location of lights and other items. Is it more convenient to have brushes and paints on your right or left side? Remember, the arrangement is for *your* individual comfort and idiosyncrasies.

If you live in a small apartment, your space is limited but that should not keep you from setting up a studio. There are two ways to do this: Designate a corner or an end of a room as your space to be set aside permanently. If that is impossible and there is not enough space to be permanently set aside, then make a portable studio which you can set up and take down.

A portable studio, while not always as convenient, is better than no studio at all. One of the most important requirements of a successful portable studio is organization. The time spent putting things away means less time setting them up again later on.

Here are some practical things you can do to help yourself get organized. Buy one or two cardboard storage file boxes for supplies and smaller equipment. Office supply stores carry these and they are very sturdy. Boxes with hand holds are easier to carry from place to place and when not in use they can be stored in a closet or corner.

Keep your paints and supplies in an orderly fashion. They can be

kept in a tray or cake pan that fits in the storage box. A pan can also be used for brushes, palette knives and other equipment. Brushes should not be crowded into too small an area, however, because you do not want to bend or damage the bristles.

When storing unpainted canvases, always put the surface on which you will paint toward the wall with large sheets of cardboard between the canvases. Grocery store cartons cut to size work well. Furniture or appliance dealers are a good source for larger boxes. Smaller canvases and boards can be stored on a closet shelf. An easel can be propped in the corner of a room and there are even easels that telescope and fold up to become small, compact bundles.

The painting you are working on, if wet, should be left out of course. Don't be embarrassed to have your work or the tools of your craft in plain view. If you played the piano, you wouldn't hide the piano would you? One artist I know decorated a coffee can, put all her brushes in it and kept it on an end table. Friends often commented on the "interesting" arrangement and one nearsighted visitor thought his hostess was displaying some unusual dried flowers!

Where should you set up your portable studio? The kitchen has some definite advantages: counters, tables and running water. The disadvantage is that it is usually the most travelled room in the house. However much trouble it might be, I long ago discovered that it is possible to juggle painting, cooking and eating schedules.

If you set aside a corner of a room for a studio, make the most of your space. Good light, natural and artificial, is necessary. If you can, be near a window. A standing or pole-bullet-type lamp is a good investment, particularly those with more than one light on the pole.

If the area you have selected has carpet, you may want to protect it by putting down a piece of linoleum, plastic or a throw rug. Once your carpet or floor is covered, you can relax and not worry about spills or splatters. No matter how careful you may be, accidents can happen. I remember once I put a paper palette down on the table and somehow missed the edge and it fell face down on the floor. I certainly was glad I had an old rug on that part of the floor.

You will need an easel or drawing board, a table or stand on which to put paints, palette and other things. If you have room, a small chest is ideal. The drawers will hold paints and brushes and the flat top is perfect for your palette. You will also need a stool or chair and a bulletin board (on the closet wall, if necessary) to place sketches, notes, etc. You will be amazed at how effective a small space can be when it is properly arranged.

There are other places you can fix up for a studio. If you live in a

warm or moderate climate, you might think about an enclosed porch. Be sure that it is snug and free from leaks. If you want to (and can afford to) you can insulate the porch and turn it into a regular room. The advantage of a porch is that it usually has a lot of windows.

If you have a dry basement and don't mind painting by artificial light, you can put your studio there. I had a basement studio once and found it very satisfactory. I had more room to spread out than I would have had upstairs; it was cool in summer and warm in winter. Because the laundry facilities were there I had running water. With a basement studio, you usually don't have to worry about splashing paint around.

Some artists have taken over the family garage and converted it into a studio space. A good garage-studio would require remodeling for lights, water and heat, but it offers a lot of space for the money.

A fortunate few are able to build studios outside their homes. One artist I know has made a lovely combination studio-greenhouse using solar energy for heat. However, the best program in any case is to look first to see what options—large or small—are available. Make do, if you must, with what you already have. As your work expands, so will your need for more and better space. And always, you can have a lot of enjoyment out of planning that "dream" studio. Sometimes, dreams really do come true!

II
"DON'T JIGGLE THE TABLE"

I think the first words I heard were "Don't jiggle the table!" My aunt was art editor for her high school annual and I remember trying to reach up to see what she was doing on the card table. The word drawing meant nothing to me but the admonition to stay away from the table was plain enough.

One friend uses a card table as her work area and has a table easel. This is fine for her because she does small pictures and has no little children to contend with. She prefers a minimum of equipment.

As I mentioned in Chapter 1, some of your equipment will depend on available space. Another factor is what you are working on. If you are painting miniatures, you obviously won't need a five-foot easel.

However, an easel is one piece of basic equipment you should have. Easels, like automobiles, come in a variety of models and prices. Usually wood or metal (aluminum) they can range from $10 to $500. Aluminum easels are lightweight and easy to move around. But unless they are the larger, heavier models, they can be tipped over by enthusiastic dogs, children, etc. Easels of either wood or aluminum when denoted as "studio" easels, are extra strong, rigid and safe. If you intend to do a lot of work outdoors, you will want a portable easel that is lighter in weight and folds easily. I have a metal easel I use when traveling. It is bulkier than an umbrella but not much longer than one when it is telescoped together. The only problem I ever had with it was convincing an over-zealous airport guard that it was not a futuristic weapon.

If you do part of your work outside and part inside, you need two easels — one for each activity. If you don't have a permanent studio, choose an easel that folds easily and is still sturdy. In these cases, I think the aluminum ones are best.

Take your time selecting an easel. Feel comfortable with it and don't buy one just because a friend has one like it. If there is more than one art supply house in town, check prices. I recently purchased a new, large studio easel and found three stores carrying identical easels that varied $25 in price. The $25 I saved bought canvas and paints.

A drawing board or work table is another useful piece of equipment. However, an old kitchen table will do nicely. There is a wide assortment of folding tables in various lengths. The sturdiest ones are carried by office supply houses. These are preferable to card tables or

the metal folding picnic tables.

Although I paint standing up, I have a stool nearby so I can sit down occasionally to see what I am doing. I use a bar stool that has a padded back and seat. At my drawing board I have a wooden kitchen stool. If you are going to do a lot of work, you should invest in a comfortable chair with a back rest.

You can buy an artist's taboret or you can, as I did some years ago, obtain a child's dresser from a secondhand shop. It has three large drawers and a side compartment. The top holds racks of paint tubes, my palette, jars of brushes, knives and an aluminum brush washer/water holder. The drawers hold everything from rags to paper.

If you have room for a bookcase, you will find it useful for not only arts books but also storing paper, copies of art magazines and some of your supplies. Metal utility shelves are very good and less expensive than a regular bookcase. You can also use boards on concrete blocks.

Those are the basic large items you will need. You might want an extra chair and a bulletin board so you can pin up sketches, notes of interest and memos of things you don't want to forget. Because I like to paint to music, I consider a radio/phonograph an essential part of my studio equipment.

Beginners often go overboard when buying brushes. Start with a minimum number until you learn which brushes you find most useful. Start out with three to six brushes of varying sizes. Avoid buying "discount" brushes: they tend to shed bristles.

You will need at least three palette knives. If you are going to use them in painting, you will want ones of varying shapes. These are the ones I prefer for painting tools:

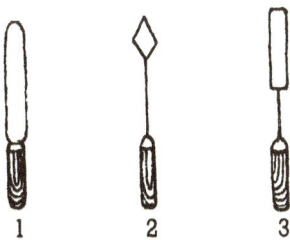

However, if you are using them just for mixing paints, the shape of number 1 is best for that — and you can get by with two knives. There are now plastic palette knives, but the metal ones are better because of their flexibility.

For a palette you can use a piece of glass, metal, hard plastic or a commercial paper palette pad. If you use glass, put a sheet of white

paper under it so paints will show their true colors. Tape edges of the glass to avoid cutting your fingers. The metal or plastic palettes come in various sizes. I find that a 9" x 12" size is the most convenient.

At first I used a piece of glass; later I used a white enameled shallow baking pan. Now I use a disposable paper palette pad because I like to save time cleaning up. I leave my pad out when not in use and cover it with a plastic cake pan lid to keep dust from settling on it — or the cat from making paint tracks.

Tin cans make ideal holders for brushes and palette knives. A tin can makes a fine container for water or turpentine. The tuna fish size works best when you want only a small amount of water or turpentine. I now use a commercial brush cleaner/water holder for water so that I can keep my brushes suspended while I am working.

When you buy paints, whether oil, acrylic or watercolor, buy a well-known brand. Cheap paint can not only slow you down but ruin a good piece of work. In selecting paints, read what the manufacturer has to say on the tube or jar. If there are any health hazard warnings, pay attention to them. If it says "Use in a well-ventilated room" — do it! Paint, turpentine, varnish and all mixing mediums will be, of course, kept out of reach of small children.

Canvas or canvas panels? Canvas panels are considerably cheaper and are a good way to start. They come in all sizes, from 5" x 7" to 24" x 20". However, not all dealers stock all sizes. Larger canvas panels may buckle in time unless framed. Canvas can be purchased already stretched and in an assortment of sizes. Canvas panels and stretched canvas are ready to use. You can buy canvas and wooden stretchers and prepare your own. However, you will have to gesso your canvas before you start painting. Gesso is a mixture of white pigment and binder. Polymer gesso is non-absorbent and flexible and is best. It can be purchased in ready-to-use liquid form and applied with a brush, roller or squeegee. Many art supply houses will "make up" canvas to your specifications but it will be more expensive than buying canvas commercially prepared.

If you plan to do a lot of outdoor painting, you will need a box to keep your supplies in. Wooden and metal paint boxes are available. I use a metal one when I travel because it is lighter weight and more durable. You can get boxes already fitted with brushes, paints and knives, or empty. Some have a place to keep paper or panels.

If you are just starting out, you may want to buy an introductory or beginners' paint set. If you buy individual tubes, you will need white, black, blue, red, yellow, green and brown. As you progress, you will want to add tubes to your "repertoire." I use about sixty-five different

colors and shades of color. I could certainly manage with fewer, but I enjoy the convenience of having so many choices. Although I often mix a desired shade of color, there is such a variety of commercial preparations now available, I more frequently use those. For example, I have seven tubes of green, from dark *phthalocyanine green* to *light green oxide*. You will find, as I have, that certain colors become favorites so you will want to have a reserve tube handy.

The very small tubes are not good buys except in silver, gold or other metallic colors — unless of course you are using large amounts of these in your work. Large sized tubes may get hard or gummy unless you use them all the time. The middle size (2 fl. oz.) are best.

You will need rags, soft and non-linty. Old shirts, sheets and cotton T-shirts make good painting rags. Oil painting rags should be kept in a closed container such as a coffee can or mayonnaise jar.

I have a paper towel holder and a toilet paper holder fastened to my painting stand. I use paper to clean my brushes, wipe off knives, wipe up spills, etc. The more expensive paper products are the best because they are the most absorbent and don't shred into pieces.

You can add other equipment as you find you need it. Don't be in a hurry to buy gadgets unless they are really going to help. I recommend a color wheel or color chart and a reducing glass. You can learn about mixing colors from your color wheel. A reducing glass looks like a magnifying glass but, as its name implies, works in the opposite way. It is like looking through the wrong end of a telescope — everything is smaller and farther away. When you are painting, you are only inches away from your canvas, but it will not be seen that way when it is hung in a room or put on exhibition. Few of us have large enough studios that we can walk back and get a long distance view of our work. The reducing glass gives the illusion of space and lets you see your painting from a distance. You can see how things blend together and whether or not details and colors work the way you want them to.

Take good care of your equipment. It will save time and money in the long run. Clean your brushes thoroughly at the end of a painting session. Never store them with bristles down. Don't let paint accumulate and encrust on your palette knives. If you have a permanent palette, keep it clean. Change turpentine and water when it becomes too dirty. And, even if you can't break yourself of the habit of squeezing toothpaste from the top of the tube, don't do it with your paints!

Finally, wear an apron or smock. It will protect your clothes and it also has a good psychological effect. When you put on your apron you are telling yourself "Let's get to work!" In winter I wear a white lab coat — well, it was white originally — but now it looks like Joseph's coat.

III
THE DELIGHTS OF DRAWING

"I had to spend an hour in the airport but I felt self-conscious about taking out my sketchbook so I just sat there," confessed my friend Marian. You will feel self-conscious at first but after a few times that "funny" feeling will wear off and sketching in public will become a habit. And yes, some people do stare or even move away, but most either don't care or are fascinated by what you are doing. I have had some interesting conversations with those strangers who were watching me sketch.

In this chapter I am talking about two different, but related subjects: One is the habit of sketching, the other the finished drawing.

A sketch pad or sketchbook is one of the most valuable tools I know. It can be a painter's diary; a source of help and inspiration when you are thinking up subjects for pictures. Sketching is a way to help you remember scenes and people. Besides sketching a scene, you should note color, shadows, time of day and other pertinent information.

I always keep a sketchbook in my purse or tote bag. Any free moment is ideal to jot down your surroundings, views, the people. Remember that sketching is artistic shorthand. You are not trying to produce a finished drawing. You are trying to capture the essence of what you see and respond to. Spontaneity should be the catchword.

Nearly everyone doodles at meetings, so try sketching at a meeting. You certainly won't be conspicuous. I have seen people sketching at concerts — I can't; I get too wrapped up in the music. However, I do go to rehearsals and sketch.

Sketch from a television program. Tune in to one that has speakers, singers or news commentators. Turn the volume down so you are not distracted and concentrate on what you see. This is especially good practice for people's expressions and gestures.

If your local art club, school art department or adult education division has a sketching or drawing class, sign up. Being in a group may help you to feel easier about sketching in public.

"I love to draw people but I don't have any models available." This is a frequent complaint that I hear. My answer is always the same — "You are surrounded by models!" We have to stop thinking of "model" in the sense of the professional poser for an artist or an art class. Your first and easiest model is you. Sit or stand in front of a mirror and do a

self-portrait. Ask members of your family or friends to pose for you. If you do find it difficult to get live models, draw from photographs, from magazines and newspapers. Illustrated sales catalogs are another good source and have the advantage of having all age groups represented from infancy to senior citizens. I find good models in the advertisements of *The New Yorker, Time, Newsweek* and the Sunday supplements. Advertisements often show men and woman close up so you can study facial structure and body features. Giving a friend or family model such close scrutiny might elicit "Why are you looking at me that way?" But one model that won't argue is your pet. I have a dog and three cats and my best drawings of them were done when they were asleep.

An artist I know likes to draw sports pictures but his small town does not offer much in the way of sports. He subscribes to a large city newspaper and sketches from newspaper photos. These form the basis for some very colorful and successful paintings.

In any of these cases — drawing from newspapers or magazines — you do not want to copy slavishing but learn to interpret what you see in your own individual way.

I am often asked if I think drawing is important. I do think it is important. Drawing is the backbone of painting. Even if you are doing abstractions, you need to know the fundamentals of drawing.

A good musician practices every day; so do ballet dancers and athletes. Artists also need to maintain their skills. Sketching is the way to practice. I set aside a short time each day to sketch.

Sketching, by definition, is rapid drawing, a quick study often preliminary to a more finished drawing or painting. Although they are often used interchangeably, drawing usually means a more careful effort, a longer process with more attention paid to techniques.

Drawing can be an end in itself or a means to an end. Many artists prepare drawings before doing a painting. Others produce drawings which are works of art in themselves. There are markets for drawings and many opportunities for exhibiting them. There are some national shows which are for drawings and prints only.

Drawing is usually done on paper. For drawings that you make to show or sell, spend the money for good quality paper. You will, at least in the beginning, want to experiment with various mediums — pencil, pen and ink, charcoal, Conte crayons, marker pens and pastels. You may find one that you prefer or you may continue to use all of them. I use the medium that seems best suited to the subject. I often combine several, producing a drawing which is labeled "mixed media." I have found that it pays in the long run to buy the best quality

pens, drawing pencils and markers — as well as paper. It is time consuming and upsetting to try to work with inferior materials.

You will also want a pencil sharpener and some good erasers. An electric pencil sharpener is worth the money if you do a lot of pencil drawing, otherwise a hand sharpener will do fine. There are also some battery-powered sharpeners on the market.

If you do a lot of drawing and have the space, a small drafting table is a wise investment. There are also portable drawing boards you can set up on your kitchen table. One friend used a breadboard but unfortunately he got ink on it and when his wife wanted to use it for baking, she was not very happy.

As with painting, to make good drawings you need to be comfortable. That means adequate light, a chair or stool that is at the proper height and a place to have your supplies at hand.

Once you are set up the next question most people ask is, "What should I draw?" You could set up a still life from things you have around the house; for example, a cup and saucer, a bottle of catsup and a spoon; or, some fruit and vegetables. It would be best to start with a simple subject such as an orange, a cup and a bottle. You can work your way up to more elaborate subjects and scenes.

When you start drawing you may want to following this suggested drawing exercise: Set up a still life and do a series of drawings. In the first drawing, concentrate on broad shapes only, on the relationship of and the spaces between the shapes. You might try using a soft pencil or a broad-tipped marker pen, charcoal or Conte crayon. After you have finished this drawing, you might decide the objects could be arranged in a different, more artistically pleasing way. Don't be afraid to change things around.

Repeat the drawing as often as needed until you have developed a feeling for the *bodies* of the objects and their *placement in space*.

Next draw the same objects but do it very rapidly. Try to capture the *spirit, not* the bulk of the arrangement. Finally, draw the objects again — this time put your emphasis on *texture, shadows* and *highlights.* In an exercise such as this, you can do the same drawing many times using different media; pencil one time, charcoal the next, etc. This will give you an opportunity to experiment with the different qualities of the various media. There are things you can do with charcoal, Conte crayons or pastels that you cannot do with pencil or pen. For example, with charcoal, you can get a softer, broader line. You can also, using a cloth or soft paper, rub in large areas. Charcoal, Conte crayons and pastels all smudge easily you so have to use extra care when working with them. I cover that part of the drawing I am not work-

ing on with clean white paper. You still have to be careful but it does cut down on the hazards of smearing.

Drawings that you intend to keep should be sprayed with a clear fixative. Drawings that you wish to exhibit should be matted and placed behind glass or plastic such as mylar. You can get the fixative at any art supply store. Read the directions carefully. Besides the rather obvious one about not pointing the nozzle at your face, there may be some restrictions on how it can be used and some ventilation requirements. When you do spray, be sure children and pets are out of range.

What about felt-tip pens, colored markers, etc? They are fine, but I wouldn't use the cheaper brands because the colors may fade. With most markers you have a problem with colors bleeding through. You can put a sheet of old paper beneath your drawing while you are working on it. I like and use a series of marking pens called *Design Art Marker*. They are manufactured by Eberhard Faber and come in a variety of nibs and colors. Some of the colors bleed but they seem to be very sharp, bright and permanent colors.

You can use all sorts of drawing equipment. Recently at a gallery show, I saw a series of drawings done with crayons. It is not unusual to see drawings that combine media such as colored pencils and ink.

Drawing can be a way of developing your imagination.

Here are some suggestions to try:
1. Draw a scene from your memory
2. Draw a scene from your favorite book or movie
3. Draw *your* version of an historical event. How to you think it was at Valley Forge that cold winter?
4. Take an assortment of small stones, arrange them in some way and see what they suggest to you. Imagine what they would be like if you were only one or two inches tall!
5. Crumple a piece of paper. What does it suggest?

Sketching and drawing are ways of developing your artistic skills and increasing your perception of the things you see. They are also a lot of fun!

IV
THE FIRST STROKE IS THE HARDEST!

Painting should be a simple act of enjoyment between you and the canvas — your hand doing what your mind and eyes see. In another sense, it is an act of love.

I taught myself to paint. You can teach yourself or you can go to a class or learn by reading instructional books. Learning options are discussed in Chapter 9 (Seven O'Clock Scholar). In this chapter I shall assume that you are teaching yourself with the aid of this book.

Just as there are many fine teachers, there are all kinds of good books on learning to paint. There are basic books such as this one; there are specialized books that deal with only one particular facet such as how to paint portraits, how to paint landscapes, anatomy for the artist, etc. I have looked at many of these but I have to confess that in some books, the directions lose me and the process of painting is made to seem too complicated and esoteric.

Here is an extremely simple approach:

BASIC RECIPE FOR AN OIL OR ACRYLIC PAINTING
1 Idea
1 Canvas or Canvas Panel
2 Palette Knives
3 Brushes (sizes 0, 2 and 5 or small, medium and wide tips)

7 tubes of oil or acrylic paint (red, blue, green, yellow, brown, black and white. Since there are different hues, I suggest you select the ones that appeal to you the most, i.e., choose cadmium red or alizarin crimson; titanium or zinc white.)

1 Palette (paper palette pad or plastic, metal, etc.)
Linseed oil - - - - - - - - - - - -
Turpentine For oils
Turpentine Container - - - -
Water - - - - - - - - - - - - - - -
Water Container - - - - - - For Acrylics
Roll of Paper Towels
Rags

Get in a comfortable position with your canvas on an easel or table. Start!

* * *

However, in case you think this seems too simple, here are more detailed instructions.

You hear about writers staring at a blank piece of paper wondering what to do next; few artists seem to have that problem. Looking at a blank canvas can be a frightening and sobering experience but usually the idea for the painting has already been formulated.

When you have an idea or subject in mind, make sure your canvas size suits the subject. For example, if you are planning a street scene, you'll want a large enough canvas so that your buildings won't seem crowded. Unless you are doing miniature paintings, it is impossible to get the Battle of Gettysburg on an 8" x 10" canvas. The reverse is also true — if you are doing a still life to exact scale, it will be lost on an enormous canvas.

Check your supplies. Do you have the paints in all the colors you are going to use? Do you have enough of those colors? It can ruin your painting time (and mood) if, in the middle of painting your sky, you run out of blue paint.

Have your brushes, knives, palette, paints, rags and paper towels arranged in the way you find convenient. Here is the arrangement I use:

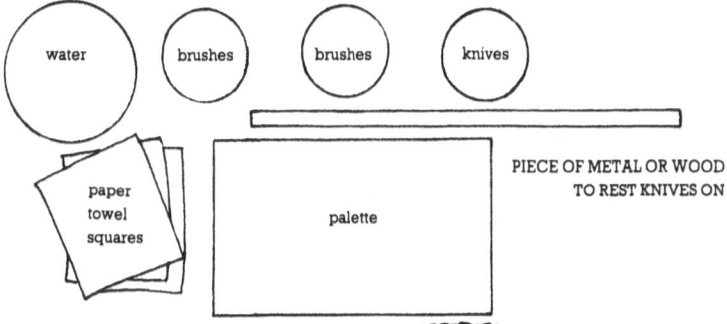

I use a commercial water container so I can suspend my brushes in water while I paint. If I were using oils I would use this for turpentine. You can use a glass jar or a tin can, but be sure when you put your brushes in it that their ends do not get out of shape. You don't want brushes that look like this:

I keep my brushes when not in use in tin cans — *brush side up*. I use two cans, a large one for large-sized brushes and a smaller one for smaller brushes. I also use a can for palette knives.

Have a clean rag and paper towels handy. I cut paper towels into four squares and have a pile of these ready. If you prefer larger pieces,

cut a paper towel in half or use the whole sheet. Having sheets torn off the roll and ready to use saves time since you don't have to stop your creative process to pull off or cut up towels.

When you're ready to paint, look at your canvas and try to visualize your planned painting. Some people find it easier to make a quick sketch on paper first. If you are using sketches or photographs as aids, they should be close at hand. You don't want to waste painting time hunting for research material.

There are three ways in which you can start your picture. You can make a wash and put in broad areas. A wash is acrylic paint thinned with water or oil paint thinned with turpentine and linseed oil. A neutral color is best to use for your brush sketch. You can also use a wash similar to the final color you are going to use. For example, use a green under grass; red for bricks, etc.

Or, you can sketch your design with pencil or charcoal. You have to be careful not to smear the drawing. If smearing is a problem, spray lightly with a fixative.

The third way is just to start painting. This is more difficult until you get your eye trained. At the beginning, you may block one item and discover you have not left enough room for the rest of your composition

Keep rags handy to wipe out paint when you need to make changes. And don't be upset by mistakes — they're all part of learning.

You can use either brushes or palette knives to do your painting. Brushes for me give greater control but many artists paint without ever touching a brush. I use knives when doing mixed media paintings on paper. Knives are excellent for *impasto* painting.

Use the right brush for the right stroke: wide brushes for big areas and small fine brushes for delicate lines and small areas. Brushes do wear out. Discard them when they become "scruffy."

Most art books talk about "setting up your palette" which means putting out some of each color, leaving room to mix your paints. Oil doesn't dry quickly so you won't lose paint by doing this, but acrylics dry very rapidly when exposed to light and heat from studio lamps. You can keep them moistened with water to retard drying to some extent. I have never gotten into the habit of putting out all my paints at once. Rather, I "set" my palette by putting out the color I am ready to use; after that one is used, I put out the next color. Sometimes I have a color plus black and white on the palette. I don't want to waste paint and I don't always know in advance what color I am going to use next.

Mixing colors is an art in itself. A color wheel or color chart can help you. Common sense tells us that adding black darkens and adding white lightens. You can mix your own shades of blue, green, orange,

etc., or you can buy already mixed tubes of paint. In acrylics, for example, *Liquitex* comes in a full range of colors.

Always mix paints on your palette with a palette knife. If you are adding turpentine (for oils), water (for acrylics) or another medium (gloss, retarder, linseed oil) use your knife.

I sometimes mix acrylics right on the canvas by painting one color and immediately, while the first color is still wet, paint over it with another, lighter color. This gives an interesting effect with the undercolor showing through. You can also do this when the under paint is dry. I find this very effective for roof shingles, buildings, brick or stone walls.

As you paint, keep a mental sign "Wet Paint" in your mind. Oils take a while to dry and I have seen some disastrous effects when an artist brushed a shoulder or sleeve against a freshly painted area. Acrylics dry more quickly but you can still smudge an area by touching it before it is completely dry. This does not mean you cannot paint wet over wet, but only that before your paints are dry, you should proceed with reasonable caution.

In mixing paints or overpainting, it is all too easy to "muddy" your colors and kill your picture. Fortunately, you can wipe out and start over, but this can be time consuming and discouraging if it happens too often.

By the way, if you need to steady your hand, get a *mahl* stick (also known as a maulstock). This is a long stick padded at one end, propped against the canvas and used as a steadying rest for the painting hand.

Each artist discovers the best way to paint. I always start from the top down. If it is an outdoor scene, I put in the sky, then the grass or sidewalk, then the street, etc. If I am doing a street scene, I leave the places for the buildings blank.

After those basic areas are done, I go back and put in the houses, people, automobiles, etc. When I do people or automobiles, I "sketch" them in with a brush, using either a white wash or *Liquitex Light Portrait Pink* wash. Friends who see the paintings at this stage call them my "ghosts." By drawing them in this way, body poses and sizes can be altered if necessary. With acrylics it is easy to erase with water or, with oils, wipe away with turpentine. Of course, the background paints should be thoroughly dry before figures are put in with this method. Once I am satisfied with the position of these figures, I add flesh color, hair and clothes.

Oil paints seem to cover well but some acrylic colors will need two or possibly three coats to get the desired effect.

In real life, you will notice that there are highlights and shadows. If

you are doing realistic paintings, you will want to add these. I use a touch of white (thinned) to get a highlight and wash of black for shadows.

As you paint more and more you will develop your own special techniques. You can get help from classes, teachers, books, but what it comes down to is what *you find best* for achieving what *you want to do.* Once you learn the basics, you can write your own program.

No matter how many pictures you paint, that first stroke of color is always the hardest — but it is also the most exciting. With that stroke *you* have started to create.

V
SPONTANEITY PLUS SPARKLE

Watercolor is difficult...but don't let that stop you. Mountain climbing is difficult too, but the thrill of reaching the top is worth the effort. You'll feel the same way when you finish a watercolor.

Watercolor is difficult because there is no room for error and correction. It is one of the most demanding of painting mediums and without the essence of spontaneity the resulting picture will look shoddy. A good watercolor must have the sparkle of a fresh work.

Watercolor paints are used on paper. You can purchase special textured paper made for use with watercolor paints. As usual, you will find it best to buy good quality paper.

Watercolor paints can be purchased in either tubes or pans. Paints in tubes keep longer and are clean. Pan paints can be dirtied by dust in the air or by color slopping over from a nearby pan.

As is obvious from the name, watercolor is water-based paint. It are transparent by nature and because of this, it is particularly good for washes.

Much of what I talked about in Chapter 4 (The First Stroke is the Hardest) also applies to watercolor.

Before you start a watercolor, *plan your painting*. If you use pencil lines as guides, remember they will not be covered by up watercolor. Either make a minimum number of guide lines, no lines or, make the lines an integral part of your composition. I recently saw an artist demonstrating book illustration. She drew her basic shapes in pencil and then, using different watercolor washes, gave the shapes volume and form. If you use ink *and* watercolor, use waterproof ink and be sure it is dry before applying watercolor. Start by applying clean water to your picture. You can wet areas with either a sponge or a clean brush. You can also soak the entire sheet in water. Your bathtub makes a good place to do this.

Fasten the paper to your drawing board or a similar flat surface with masking tape. As the paper dries, it becomes as tight as a drum. This prevents sagging and buckling with the attendant pockets which can collect paint and ruin the crispness of your picture.

If you use the finest watercolor paper that comes in a block, the paper is already tight and firm since it is bound on all four sides.

Illustration board can also be used.

One of the characteristics of watercolor is that the white of the paper is the white of your painting. To achieve the desired highlights, requires lots of practice. When you apply watercolor, use a *rhythmic stroke*. For even coloring, overlap the strokes. Tilting your paper will allow any excess paint to pool at the bottom of each stroke so it can be picked up and moved forward with the next stroke.

The transparency of your colors will depend on how much water you add to your paints. Adding water directly to a painted surface will make a color fade away, a good effect for skies and backgrounds.

You can add one color over another. If the undercolor is dry, you can wet the paper before applying the new wash. The second — or third — color should be "floated" on the paper. Don't use your brush as if you were scrubbing a floor.

After the basic washes are in, you can put in various details and accents using a dry or wet brush. You can get some interesting texture effects by using a sponge, either natural or synthetic.

Accents can be placed in a set area but, again, use a light touch.

Watercolor requires more practice and patience than any other medium. It is also the most fragile. The watercolors you want to display should be matted and protected by glass or plastic film.

VI
SUBJECT & STYLE OR "I KNEW THAT WAS YOURS"

Paint what you want to paint. If you feel the urge to paint flowers, do it. If your friend is painting cows and you would rather paint automobiles — paint automobiles! I don't paint rural scenes. I have nothing against the country, but I am a city person and prefer sidewalks to leafy lanes. Besides, my country experiences are very limited. I like to paint *what I know*.

Selecting the proper subject is a hurdle that sometimes stops a potential artist from beginning or continuing. There are a couple of general rules that can help: you should select a subject in which you are interested and, at first, one with which you are familiar.

In talking with amateur artists who have started paintings and never finished them, I have found that a major reason was that they lost interest in the subject. Without interest, painting becomes *work* not *fun*, so the unfinished canvas goes into a closet, attic or garage. Many times the beginning artist lost interest because the selected subject was beyond his/her immediate range of knowledge and ability.

When you select a subject, be sure it will last through the entire painting process. This is particularly important if you are only able to paint on weekends. Painting a scene at intervals from life without using sketches or photographs can result in some rather unpleasant and unwelcome surprises. One artist I know found an old building she wanted to paint. For two weekends she worked at the site — on the third weekend when she arrived on the street, to her horror the building had been demolished.

Another artist complained that his still life models of fruit and vegetables withered before he could finish his paintings. He eventually found a solution — artificial fruits and vegetables. Now he takes as much times as he wants and visitors don't say "It smells funny in here."

While challenge is good for you, it is best to select subjects you can handle. Learn by doing but don't try to learn everything in one painting. Each successive painting will become easier because of what you have learned, but each painting also becomes harder as you extend your own limits and reach for greater diversity.

Certain artists find a subject they like and do it so well they never do anything else. I personally find this too confining. In the same way,

actors become typecast. You as an artist, can put yourself into a specific category which becomes your style. When your pictures are shown, people recognize them as yours. They point and say with pride in their own artistic sense, "I knew that was yours!"

This is only good if, within their sameness, your pictures have some individuality.

For example, I recently attended an art show of some fifteen large paintings. The central figure in each canvas was an Indian mythological creature, presented in fifteen different situations and backgrounds. There was unity in the show but also diversity. On the other hand, I have gone to exhibitions where a series of paintings all looked alike except for minor differences in color. They were boring. Any one canvas by itself would have been interesting but a roomful did not titilate either the senses or the intellect.

Style is your way of interpreting what you see and feel. Style "happens" to your art as you work at it; it is not something you can copy.

Once you become known for certain subjects or develop a style you feel comfortable with, don't let this keep you from trying new and different ways of dealing with the familiar or unfamiliar. Never be afraid to experiment.

A successful painter once told me, "I've done very well with my pictures of children but I wish that I had the courage to try some other subjects. I feel unfulfilled as an artist."

From 1952 to 1967, I made prints — serigraphs. The were either abstractions or still life subjects. After developing a weakness in my hands I gave up printmaking. Although I did some drawing, it was not until 1975 that I returned to art. This time I did oil painting and later switched to acrylics. I had tried oils years before but quickly gave them up for, at that time, they didn't "suit" me.

From 1975 until 1981, I painted exclusively in a folk art style but one day I decided to experiment and develop a second style that I use in what I call my "fantasy" paintings. Now I have two ways of seeing and interpreting the world around me.

Don't develop tunnel vision in your art. Find your subjects and your style will find you — again and again if you're lucky.

VII

LOOK IT UP OR LEAVE IT OUT

I was doing a painting of a 1920-style kitchen, certain that I remembered how the handles and hinges of a wooden ice box looked. However, to be sure, I checked in my file for pictures of ice boxes and references to them in books.

"I've just been asked to do a drawing with a 1935 automobile in it and I wish I could remember what it looked like," an artist friend telephoned me one night. "I'm sure the library has the information but it's closed and this is a rush job!"

"Look in your *idea file.*" was my answer.

Silence. Then a small voice said, "I don't have one. I meant to start one after I saw yours. Do you have a picture of a 1935 car?"

I did and he came over and borrowed it. Now he has his own idea file. What is an idea file? It is a resource tool, a collection of clippings, pictures, notes, sketches and related material.

My idea file is so useful that I sometimes call it my "million-dollar" file. Well, perhaps that is too optimistic in terms of actual cash received — but it sounds more impressive than my thousand-dollar file.

Of the principal ways in which the file can be used, one is to help you to verify details.

At other times you will want some help in deciding on the style of clothes you are putting in a picture, the position of windows in a house, how a well-known advertising sign looks. For example, you have decided to paint a country scene with a barn. You go to your idea file for the folder marked "barns" and you find that you have several pictures of different types of barns to study. These are pictures you have cut from magazines or newspapers, perhaps some photographs you have taken or some sketches you have made.

Another important use for your idea file is to *stimulate your imagination* and to help you over those moments when you are stumped, wondering what to paint next. Looking through the file may give you an idea or remind you of a subject you have wanted to tackle.

The exact composition of an idea file will vary with the individual artist and will also, undoubtedly, change from time to time. In other words, your file will reflect your special interests and needs. You are making the file for yourself.

Malinda, who paints animals, has an idea file that includes pictures

and descriptions of cat, dogs, horses and deer — all animals that she uses frequently in her paintings. If you are doing city scenes, you will probably want to have pictures of buildings, streets, automobiles, stores, etc. If you do room interiors, you will want information on furniture, curtains, rugs, wallpaper and room arrangements. I collect anything that has to do with the '20s and '30s, especially houses, automobiles and clothing. I also look for people in various poses. And, because I do pictures with musicians, I collect pictures of musical instruments and of people playing the instruments. There is really no limit except your own willingness to spend time clipping and filing material.

I keep information on favorite artists, clippings of local art reviews and area art news. Such items are useful because you should be familiar with local and regional art happenings.

Material for the idea file can come from newspapers, magazines, any printed media — even letters from friends and photographs.

Here are some common sources and what you might find in them:

Newspapers are good for action pictures. They show people doing a variety of things and are also a source for group photos, faces, furnishings, clothes, automobiles, animals, houses and buildings.

Magazines give you much the same but usually with the advantages of color and better photos. Magazine illustrations are particularly good for scenes, buildings and people. Don't overlook advertisements. They show people in a variety of places and settings such as sitting around a table eating, having a barbecue, visiting in a living room, etc.

Catalogues of all kinds are excellent sources for people, clothes, equipment and furnishings. Sales catalogues from mail order houses or the big chain stores are gold mines of information. Seed catalogues will give you pictures of flowers and vegetables.

Postcards are a source of information for buildings, city scenes, fountains and historic sites.

Advertising leaflets usually receive only a quick glance before they are consigned to oblivion but not if you are an artist with an idea file. In the past few weeks, I have picked up leaflets with pictures of amusement parks, beach scenes, old trains and antique automobiles.

Naturally, you don't want to cut up books but you also don't want to lose track of important information or illustrations There are two ways to handle this problem. One is to Xerox the pages you want; the other is to make a file reference sheet to the appropriate pages noting the title of the book.

I find copying the most advantageous for books I don't own — library books or ones borrowed from friends. Be sure to write on the copy the source of the page: the author, title and date of the book. You

may also find it useful to indicate the book's location. A few weeks ago, I copied several pages of advertisements from some old library magazines and because these showed styles, kitchen utensils, furnishings and prices, I made sure that the year was on each sheet. It's not always easy to remember if something was from 1925 or 1932.

With my own books, I make *reference sheets* for my idea file. Since these sheets are going into my file, I use 8½" x 11" paper. You can use scrap paper that has already been used on one side. Put a heading at the top of the sheet, then briefly list the author and title of the book, the page or pages where the information is located and specify whether the illustrations are in black and white or color. If there are no pictures but only descriptive text, indicate that. It can be annoying to go to a book for a picture and find only words. Always be sure that your information is accurate and legible. You can add additional information to the sheets as you continue your reading and research.

STREET CARS

Rolfe, J. Transportation Topics. pp. 34-37. Color.

Smith, T. Our Earlier Forms of Transportation. p. 29, B&W
pp. 62-67, Color. p. 79, description only

Braney, S. History of St. Louis, pp. 10-12, 34, B&W.

Snapshots & Slides can also be a part of your idea file. Protect them in plastic sleeves which you can get at a photo supply store.

By being alert and responsive to your own needs, you can find material for your idea file in many different places. I once startled a dinner hostess by jumping up and down when I saw her paper napkins. They had pictures of famous bridges on them and when I explained the reason for my interest, she happily offered me a set of the four designs plus one to use so I did not have to surreptitiously use my handkerchief or sleeve.

I have acquired material from placemats, calendars, stationery, wrapping paper and product boxes — even small boxes of Kleenex which at one time were put out with illustrations of early automobiles on the bottom of the boxes. Once you have started accumulating material, your next solvable problem is how to keep it in order.

Don't put things in a box and then rely on your memory to tell you where to look. The only semi-successful box method I have seen was one used by a friend who had lots of space and lots of empty typing

paper boxes. His idea file was limited to a few broad topics. Each box contained one subject. You can see the obvious drawbacks to such a system — it cannot be too detailed and boxes take up a lot of room.

I recommend keeping your idea file in a filing cabinet, using either letter or legal size file folders. You can buy metal filing cabinets in two to five drawer sizes in all office supply stores and at most department or discount stores. If you do not want to invest in metal cabinets, there are good quality, heavy-duty cardboard file drawers, some with reinforced metal corners. These usually come in two-drawer sizes and are relatively inexpensive. You do have to put them together but the directions are easy to follow.

You will also need a supply of file folders and a pen to mark the category on the folder. If you prefer, you can get file folder labels and type your headings.

Arrange your folders alphabetically by subject. If your idea file grows to be very large, you may want to have a card index to the contents. Use 3 x 5 cards and type or print the headings — one to a card. The cards should be filed alphabetically in a file box. These also come in either metal or cardboard.

The advantage to a card file is to indicate subjects which are covered in the file but do not have separate folders. You can also indicate related topics and cross-reference topics.

GLASSWARE
See:
DISHES, GLASSWARE

MERRY-GO-ROUNDS
See Also:
AMUSEMENT PARKS

If your studio is large enough, keep your filing cabinet there. If not, have it as near by as possible. Remember, it is part of your working equipment.

John N., who has an extensive file on houses, architectural history and home decoration, doesn't have room in his studio for his files; he keeps them in his garage. However, he does have a card file in the

studio so he at least knows what to look for when he goes to his files.

Your books should be kept in order if they are to be a viable part of your indexing. Depending upon the size of your collection, they can be arranged by author or by author within subject divisions. I have about 300 books in my studio collection and they are arranged by subject first, then by author.

If all this talk about arrangement seems too compulsive or "non-art," remember — it is easier to paint when things are in order than to struggle along in chaos. You save time in the future by keeping things organized in the present.

Your art library will naturally reflect your special interest. There are many good books on technical skills. You should have at least one book on art history. Another book that will prove useful is a dictionary with illustrations. A dictionary is often the most reliable source for pictures of animals, fish, plants, objects, etc.

In my library I have reprints of early sales catalogs from such stores as Sears and Kresge. I also have books on life styles in the '20s and '30s and, of course, several books on folk art. There are some artists whose art I admire and I have made it a practice to collect books and articles about the lives and works of those artists.

Indexing is the best way to get maximum usage out of your books. For indexing to work, you need to keep your books in order. Having a reference to a page in a book isn't much help if you can't find the book itself.

If you are in doubt about how something looked and you are striving for authenticity, the rule should be *Look it up or leave it out!*

VIII

"WHICH BUTTON DO I PUSH?"

"I can paint a landscape but I'm all thumbs with a camera," my friend Jane recently grumbled.

Fortunately, there are a variety of cameras on the market that are both simple to operate and inexpensive. I like the cameras that take 110 size film cartridges. My first instamatic camera was the cheapest Kodak made and, although I now have a more expensive 110 model, it still costs under $60. With a good telephoto lens enabling me to take close-ups and a built-in flash, I have all I need. I also own a camera that uses a 126 film cartridge and I use this for color slides.

If you are like another friend of mine, you may ask, "As an artist, not a photographer, why do I need a camera at all?"

As an artist, you will find a camera useful for several reasons such as making a visual record of your work, collecting items for your idea file and taking notes for present or future paintings. A camera can be used to keep a record of your art activities and photographs and slides are good selling tools. I recommend a camera as part of your studio equipment. The question is what kind to buy. I suggest two cameras: one for snapshots and one for slides.

In Chapter 16, Satisfying Your Ego and the IRS, I mention you should have a snapshot and/or slide of each painting you complete. These can be photos you take and do not need to be masterpieces. You are not going to be able to remember all the pictures you paint, especially the details, shades of color, arrangement of shapes, etc. You may remember "Afternoon at Spring Lake" as a painting with a blue sky — but was it? Your photographic records will refresh your memory.

The question of whether to take snapshots or slides often comes up. As I have indicated, I take both but you have to ask yourself how you intend to use them. Snapshots are easier to file and use but slides are usually needed for entering shows and sending to galleries. I send snapshots to potential clients unless they specifically request slides. A lot of people don't have a slide projector or a viewer handy and find slides awkward. I remember one occasion when I sent snapshots to a collector in St. Louis. She made a selection and then, while in Washington DC on a business trip, showed the snapshots to a friend. He telephoned and bought a picture and then showed the snapshots to a friend of his who later wrote and purchased a picture. In that case six

snapshots and 20 cents postage added up to the sale of three pictures!

There are times when slides are called for. Most galleries prefer them and if you are affiliated with a gallery, they usually will tell you what they want. The gallery that handles my work is responsible for making color slides and I am responsible for making 5" x 7", black and white prints of each painting. The black and white photos are for publicity purposes and sales catalogs.

When taking your slides or snapshots, it is wise to remember a few simple rules. Look for a neutral background. A museum photographer I know says he uses a white sheet of heavy cardboard. Another professional photographer uses a black background. With the telephoto lens of the instamatic camera, you can eliminate background altogether and your photograph will just be of your painting. Unfortunately this does not work with large paintings. I find that a plain light-colored wall does nicely for inside shots and a fence or outdoor wall gives a good neutral background for outside shots.

I must warn you, however, about wind and shadows. Don't attempt to photograph on a windy day unless you want to see your painting go sailing over the fence! And do pay attention to shadows. I once got a snapshot back with a series of strange dark lines and blobs on the canvas. My painting was okay but when I photographed it, I didn't notice the shadows of the bushes behind me.

Avoid extraneous things in your snapshots or slides. Your painting should be the main focus, not your dog or the wash on the line!

If you frame your work under glass or plastic, take your pictures first. It is almost impossible to avoid glare, distortion or reflection when the glass is in place.

No matter how good your snapshots or slides, they won't be useful until they are properly labeled. This is the information you need:

>Title
>Size
>Medium
>Your name and address

In addition, it is wise to mark the word "top" if your painting is one that is abstract. We've all heard those horror stories about paintings being exhibited upside down.

This information can be typed or printed on a self-adhesive label and put on the back of your snapshots. I use a 1½" x 3" size label. If you print the information, cover the label with transparent tape so the ink does not smear. I had two snapshots ruined by ink stains before I remembered to do that. If you write directly on the back of the snapshots, the lines will show through on the face side.

> SPRING NIGHT
> 18 x 24, oil on canvas
> Tom Bellanto
> 1432 Ringo Sq.
> Cleveland, OH

Information can be printed on the slide holder and slides should be placed in protective plastic sleeves which can be purchased from any photographic supply store.

Your camera can be used to supplement your sketch book. It is particularly handy when you see a building or a scene that you want to remember but don't have time to sketch. There are also places so busy with traffic or otherwise inaccessible that you simply can't stop to sketch. So, you use your camera instead to collect for your idea file and to take notes. John N., who specializes in paintings of homes, takes photographs of all possible views as well as making on-site sketches. He takes close-ups of any distinctive architectural features. The photographs help him recall the exact position, color and detail for any part of the house he is painting.

Once I was asked to to a "portrait" of the front of a house. I spent the weekend with my clients, sketched and took snapshots. A few weeks later, and 800 miles distant, I discovered I had not sketched the outside light in as much detail as I should have and I didn't feel I could trust my memory. Fortunately, one of my snapshots showed the front door and the light. Another time, a snapshot gave me the exact shade of roof shingles I needed to complete my picture. Photographs are also helpful if you are painting outdoors on location and can't finish because of time, darkness or weather. They help to recapture the scene for you when you are back in your studio finishing the painting.

Keep a record of your art activities with photographs. Whenever you are in an art show and it is possible to take pictures of the exhibit, do so. If you are in a gallery, take pictures of the gallery and of your art work. Such memorabilia can be useful later on.

If you are going to give lectures or demonstrations, it is helpful to have a photographic record of the various stages of a painting, perhaps ending with a picture of it being exhibited in a show or gallery. Slides are best for this since they can be projected on a screen.

I am often asked what I think of the technique of projecting a slide onto a canvas and painting a picture from the image. I think this is unacceptable and is merely a sophisticated form of copying. The slide or snapshot should be an aid and you should use it as you would use any

preliminary sketch — as a guide and a reminder. To use them otherwise shows a certain lack of faith and confidence in one's ability as an artist.

As an artist you have the advantage of rearranging things, changing colors, adding or subtracting as you wish in your paintings. The camera is a cold, mechanical eye. It can't record your emotions and your experiences — that is why you are an artist.

IX

SEVEN O'CLOCK SCHOLAR

"I need help in learning more about art," admitted Fred N., "but I can't decide how to go about it. Should I take classes, read books or look for a private teacher?"

As a beginning artist, you can explore the learning possibilities available to you for you can learn about art in a number of ways. Art classes are an obvious choice. If you live in a city or metropolitan area, you will have more to choose from in the way of art instruction.

Most museums offer classes in various techniques. Many colleges and high schools have adult education programs that include classes in painting, drawing and other subjects of interest to artists. These are usually night classes. In some towns there are private art schools or academies. In my town (Santa Fe, New Mexico) a local art supply house offers a regular schedule of classes, all taught by resident professional artists.

If you live in a small town or rural area, you may have to commute to classes. Another possibility is to find a local teacher, get a group together and create your own classes.

Be warned — not all artists make good teachers and not all teachers suit all students. Don't be dismayed if this happens to you.

"I love Mr. Swinton's paintings," complained a friend, "and I couldn't wait for his art class to start, but I don't like him as a teacher. He may be okay for some, but I don't feel I am learning what I need. I think he expects students to have more experience than I have had."

It's wise to check in advance exactly what a class offers. If there is some doubt in your mind, talk to the instructor or to someone from the sponsoring institution. Don't be hesitant to ask questions. Remember, it is your time and your money. If you have too many doubts, ask if you can sit in on the first class before making a decision.

Classes are very good if you have problems in self-discipline Once or twice a week you are going to have to devote a certain amount of time to art. Classes mean having a regular schedule to adhere to and follow. You will also find that it can be creatively and mentally stimulating to be among other artists.

A beginning artist told me recently: "Some nights when I finish work, I think I'm just too tired to do anything; but Tuesday and Thursday I make myself to go my art class. At 7 o'clock when class starts, I

forget I'm tired. Time flies and I'm always surprised when the teacher tells us it's time to pack up!" She went on to say that she was learning a great deal from the informal conversations between fellow students.

I have a friend who spends her vacations taking art workshops in various parts of the country. This gives her a chance to combine travel with study.

Learning is not confined to classes or workshops. If you are unable to attend a group class, there are a number of correspondence schools. As with selecting a teacher, you should pay attention to what is offered and whether it will meet your needs. Ask for complete information about how the course is conducted, how the money is to be paid and what you receive for your money. If you have any questions about the current status of the company, write to the Better Business Bureau in the city where the school is located. You can also write to the Consumers' Division of the state. If there have been problems or complaints, better find out before you enroll.

Information on art schools, workshops and seminars can be found in art magazines. *American Artist* is a particularly good source.

You can also learn from books. There are how-to art books on every facet of the subject. For a basic self-help library, you will want to have books on drawing, on perspective and on the medium you are using. There are also books on portraiture, animal drawing, landscape art, architecture, seascapes, etc. An art supply store is the best place to look for practical art books. There are many inexpensive paperbacks available.

If you do not want to start out buying books, head for the public library. I learned to do serigraphs from library books. Then, when I found how much I enjoyed making them, I bought my own books.

Magazine articles are a good source of self-instruction. One of the best is *American Artist* but you can learn from any art magazine. They may not have 1-2-3 directions but by studying the illustrations and the text you can add to your artistic knowledge.

Some art supply stores distribute copies of *Palette Talk*. It is free and, although small, it is full of suggestions and how-to articles.

Check your local TV station, especially the PBS channel, for art programs. Whether it is one of the art demonstration programs, art history or a look at an artist's work, it can be helpful to you. Along that line, I rcently saw an advertisement for a video cassette that offered a step-by-step approach to painting pictures.

Observation of others' work is still another part of your learning process. Go to museums and galleries. Study the art on display with an eye to what the artist has accomplished. How were perspective problems

handled? How were shadows, light and color used? Examine each work with the idea that it may have something to add to your individual learning experience. For instance, I learned about painting street curbs after seeing a large mural of a street scene in a cafeteria.

The best and most natural experience for any artist is to become a professional looker. Drawing and painting will increase your powers of observation and you will find that you look at people, animals, landscapes — in fact your whole world with new eyes and greater concentration. As you observe how things look, how shadows form, what light does when it changes — you unconsciously absorb knowledge that increases your artistic skills.

X
THERE IS SAFETY (& SOLACE) IN NUMBERS

"Hey, can I be in your gang? Gee, do you mean I can finally be a member of the Secret Seven?" are echoes from our collective pasts but the desire to belong to something usually stays with us throughout our adult lives.

And it is a natural human reaction to want to get together with other people who share our interests. In art, as in other activities, the old adage "safety in numbers" has some merit. It is comforting to share our discoveries and doubts with others. While some artists prefer to work alone, others reach out for some mutual artistic companionship.

If there is an art club or society in your community, you should investigate its membership. You may find it encouraging to be in a learning situation with others who share your interest and enthusiasm. It provides a forum for questions and suggested solutions to art problems. Frequently clubs have guest speakers, museum tours and gallery visits. All of these events will make you feel a part of your local art scene.

There are some other advantages to belonging to an organized art group. Some art magazines offer savings in subscription prices to art clubs. Many art groups have an annual exhibit which gives you an opportunity to show your work. This is particularly helpful when you are a beginner and, perhaps, a bit timid about exhibiting for the first time.

Some words of warning — most art groups, especially if they have been established for any length of time, have minimum requirements for membership. This usually means that you have to submit samples of your work to a committee. Sometimes there is also a personal interview which gives you an opportunity to talk about your work, your goals and other pertinent facts. Sounds scary, you say? Yes, it can be, even with the kindest committee members, but once you are accepted all that is forgotten and you become one of them. You may even wind up on a screening committee yourself.

Another word of caution — don't expect every one in the group to like your work immediately. Don't expect praise and never criticism. At the same time, don't be intimidated by the "old hands" in the organization. I have made some lifelong friends but I have also met some individuals I found difficult.

Fellow artists tend to be harder on each other than the general

public. Being able to cope with group remarks is a vital part of your art club life. I remember one art group to which I belonged: We met weekly and brought in our work for group scrutiny. For the newcomer this can be a devastating experience. One of the founders of the group was an older woman, the "grande dame" of the organization. As the committee would set out a picture, she would stare intently and then comment at length. If she did not recognize the artist's work, she would roar, "Who did it?" The first time that happened to me, I tried to sink out of sight. My painting turned to ashes before my eyes. After an impatient "Well?," I managed to squeak out a response. As it turned out, there was one thing she thought was quite good but there were areas where she thought I could improve. Later I discovered that she was usually right. She had a keen eye and artistic sense and, combined with her academic art background, she was an excellent critic and teacher.

This group, like many other clubs, not only had a yearly exhibit of members' works but a number of shows during the year. They had small group shows, two person shows and, occasionally, sponsored a one-man show. It is interesting to note that they started out by exhibiting at the local library, college hall, restaurants and city offices and, in 1979, they were able to buy a store front and convert the building into an Art Association Gallery managed by the membership.

In another city, a friend belonged to a small art club. Each person paid a small fee and the group hired an art professor from the university to meet with them once a week for three months. They met in their homes and took turns having the group. Because they were a small number, there was plenty of time for individual help. By the end of the three months, a strong sense of camaraderie had developed. The professor was impressed by their diligent attendance and hard work and helped to arrange an exhibit for them.

A friend wrote to me: "I've settled in my new house and even have my studio set up but I miss the give-and-take of the art club I belonged to before." I advised her to start a new club in her new city. Anyone who really wants to take the time can organize such an art club.

My friend, being a recent resident, did not know other artists, so she put a notice in the newspaper about an organizational meeting. She also contacted an art teacher and a local art supply store. Although she was living in a small town, 14 people turned out for that first meeting

In planning your own meeting, pick a location that is easily accessible and has parking. Public libraries often have community rooms that can be used. Some banks also have such rooms. Meetings can also be held in church social halls, city recreation areas or lodge halls.

Once you have a core of interested persons, you can select a name,

decide on the frequency , place and purpose of your club. To insure continuity, you should elect officers. Dues, if assessed, can be used to defray expenses of an annual exhibit of works. By keeping the public informed through newspaper and radio announcements, you will build an appreciative audience for your exhibits.

Art clubs can vary from loosely-organized affairs to more structured associations. Many cities have local chapters of the national organization *Artists Equity*.

It has been my experience that it strengthens an art club to have both professional and amateur members. Professional artists can, if they are willing, share their experience and expertise so that beginners can learn how to make their way.

XI
"I CAN DO *THAT*"

Show me an artist who has never been told, "Why, I could do that!" and I'll show you an artist who has never shown his work to others.

There is always the temptation to reply, "Well, why don't you!". But most of us simply smile, a little weakly, and mumble some vague words.

People are always going to feel free to comment on works of art. And, if you are going to show yours, either publicly or on the walls of your home, you are going to get comments, positive and negative. Occasionally, you will get a downright insult — for no apparent reason.

Ellen, an accomplished amateur artist, never attended the opening receptions of exhibitions sponsored by the art club she belonged to.

"How can I get over being afraid of what people are going to say about my art?" she asked. "By growing tough skin," I told her.

Any individual who does something in public becomes a candidate for suggestions, advice and criticism. It probably started with the first drawings on cave walls! You have to learn, as Ellen eventually did, to accept all kinds of comments and tread the middle ground between elation and depression. If you have done your best, you should be able to accept appreciation or criticism gracefully. Don't let the fear of what people will say keep you from the enjoyment you receive from your own art or from a willingness to display it.

As a naive—or folk—painter, I have had my share of comments. Usually people relate well to this kind of art but there are always some who say, "My children paint like that," the implication being that an adult ought to paint in a more sophisticated manner. One person snorted, "It looks like comic book art!" And there was the individual who asked, "Have you ever thought of taking lessons?"

But all that is forgotten when someone says "I like that. Reminds me of when I was growing up," or, "Yes, that's the way things feel on a hot summer day."

If you paint abstractions, there are always people who ask, "What is it?" I have discovered that some viewers are at a loss when looking at art. They don't want to show their ignorance and, in their embarrassment, they may come out with an unexpected comment. Praise and criticism are part of learning.

Always remember to consider the position and knowledge of the person making the remarks. What is his or her art background? How

valid are the remarks? The comments of an art critic and the comments of your Aunt Mary are not taken with the same weight unless, of course, Aunt Mary has an art background. By listening to what people have to say, you can get an idea of how *they* see your work. But don't forget, they could be wrong. Ask yourself what you are attempting to do and then evaluate whether you feel it has come across to those viewing your painting. This can be a test of your ability to communicate, providing your audience is equal to the task.

If you have a gallery representative, teacher or agent, listen carefully to what they have to say about your work. Examine all suggestions carefully. Just as an editor can help a writer, these people can help you. If you don't agree with what they say, explain why you did what you did. Don't be afraid to enter into a debate with anyone or to defend your point of view. On the other hand, don't be so stubborn that you can't learn from what others say. Usually they are only trying to help.

I remember when I was beginning I took some pictures to a gallery. The manager liked the paintings but not the frames. She pointed out that they were too ornate for my work. She was right and I had not noticed it. From that time on, I have used simple frames which complement my subjects and do not overwhelm them.

"My friends think I'm a genius. I think I'll quit my job and devote myself to art," said a neighbor. It's wonderful to be so enthusiastically supported by your friends but don't jump to dangerous conclusions! Whether you are a genius or not, making a living at painting is, at best, extremely precarious. The majority of artists have to find another way to make a living, at least at first.

Once you are established with regular sales, you can think about being a full-time artist. If you are fortunate, you may be able to make your living in an art-related field such as advertising, graphic design or teaching. But try not to despair if you have to wait for retirement to become a full-timer — the important thing is that you are painting.

Another acquaintance, Ann, remarked. "My husband says I am wasting my time painting. I should take up bowling." Whether or not time is being wasted is, of course, dependent on the joy and/or fulfillment you receive from painting. And only you can answer that.

For your own peace of mind, you have to learn how to handle what people are going to say about you and your art. There is no formula for such situations. Just remember that being an artist is not easy. If it were not for the adversity, there would also be little challenge. And that is all that separates a great bowler from a great painter.

XII

THE PUBLIC EYE AND THE PRIVATE ARTIST

To be or not to be — a public figure! You may dread the spotlight but if you are going to be a successful artist, you will have to deal with it. If you want to sell your art, you will have to find ways to let people know *what you do* and *where you do it.* Some publicity may be in the form of paid advertising. Other kinds of exposure can be gotten free.

Probably the most fundamental way to let people know about your work is to have a brochure printed. This can range from a black and white sheet done at a quick print shop to a four-color brochure prepared by a big commercial printer. One or more photographs of your work should be included along with a picture of yourself. In the text, list places you have exhibited, honors you have received, your educational background, if pertinent, and any comments of reviewers.

Obviously you will choose comments that have something positive to say about you and your work. Critics are only human and may have bad days so if a critic has stated "The pictures resembled big feet chicken tracks," it might be well to not refer to that remark publicly.

Some artists include a statement of their philosophy or goals. The important thing is to make the brochure informational.

You should hand these leaflets or brochures out to friends, family members and, when possible, to strangers. Look for places where you can display them. An art supply store in my town has a table on which artists can put copies of their brochures. Community centers, public libraries or commerical establishments often have public interest bulletin boards where you can thumbtack material. A brochure is a silent salesman and if yours is attractively produced, it will bring you business.

Calling cards are another way to keep in touch with the public. Besides your name, address and telephone number, give a brief mention of your specialties or medium.

PORTRAITS BY
John McMarric
239 Sixth Street / Santa Fe, NM 87501
(505) 938-9839
PORTRAITS IN OIL, ACRYLIC OR PASTEL

As with the brochures, cards can be handed out, tacked up or left in places where people are apt to pick them up.

If you have art to sell, you may want to run either a classified or display advertisement in the newspaper. More costly but definitely better is magazine advertising. Most cities today have magazines of regional news and interest. Some churches and other organizations accept advertising in their bulletins. Advertising in specialized art magazines is rather expensive. Other special interest magazines are among the best places to advertise. I have seen ads for animal paintings in cat and dog magazines. An artist who specializes in rural scenes can advertise in farm magazines and in a popular house / garden magazine, I recently saw an ad offering to paint a portrait of your house.

Free publicity requires a little work but can be very rewarding in terms of public interest and possible sales. Most newspapers do human interest stories on local people. Send a note to the paper detailing why you think a story about you as an artist would interest readers. You might enclose a snapshot of your work. If you notice that a particular feature writer does such stories, send your information to his attention.

if you are in a show in another geographical area or if you win a prize there, notify your hometown paper as well as the place where your work is getting recognition.

Many local radio and television stations have interviews with local people doing interesting things. Again, you have to let them know who you are and what you are doing.

Frankly, you will have a better chance of getting local publicity in a smaller city or town. However, people are always interested in what their neighbors are up to and, as an artist you should receive some special attention, providing your work warrants it.

Company, fraternal, religious and other organizations that print newsletters with information about their employees or members are other places you can approach with your achievements and activities.

You can also become better known by taking part in civic and community affairs. Be willing to donate your time and talent to design a poster, illustrate a program or booklet. Not only is it good practice for you but it will enhance your reputation.

Don't back away from self-promotion. If you have confidence in yourself as an artist, then you should be willing to share yourself with the public eye.

XIII

SHOW & TELL

The first time you exhibit one of your paintings is not only the most exciting but also the most frightening. A friend of mine said her first exhibit made her feel as if she were taking a bath in public. I know the first time I took some prints to an exhibit, I wrapped them in brown paper so no one would see them. Anyone seeing me slinking through the streets would have thought I were sneaking pornography.

When most of us imagine "exhibits," we think of museums and galleries. But not everyone has the degree of skill and success that will guarantee them a museum or gallery show. Certainly, it is rare for a beginner to start out with that kind of an exhibit. Many artists will never show in a museum but they will get to show (and sell) their work to the public in a variety of places.

"I'm not going to show my paintings anywhere except in a *real* gallery!" Mrs. S stated. And, true to her word, when an art club to which she belonged arranged to have an exhibit at the local shopping mall, she refused to take part. As far as I know, she still hasn't shown her work publicly. Her work is good but not spectacular and since her town has no art galleries and she hasn't bothered to contact any outside her area, she may never have an exhibit. Wanting a gallery to contact you is a wonderful dream but in the meantime, why not show your art work when and where you can? Who knows — a gallery owner may spot your paintings somewhere and contact you after all.

There are all kinds of places to show your art. I have exhibited in banks, libraries, restaurants, government offices, malls, sidewalk shows, stores, galleries and even in a tennis clubhouse. One group show in which I participated was held on a weekend in the local Merrill, Lynch offices. The promoter of the show, an art teacher, contacted local artists, got newspapers and radio publicity, put up posters in public areas and made sure that all the artists represented were present in person to meet visitors. The show was well-attended and sales were good.

As already discussed, group exhibits are a good way to start. The requirement in terms of output is less taxing and expenses are usually split among the participants.

If your art club or a group of you are arranging a show for yourselves, here are some ground rules to help you get started:

 1. Have a unifying theme that can be promoted in advertising.

2. Divide the responsibilities among everyone participating.
3. Be discreet in assigning responsibilities to those who will be most capable of completing that task.

In selecting exhibition space, these factors should be considered:
1. Location and parking: You want to make it as easy as possible for people to see the exhibit.
2. Hanging area and lighting: You want to be able to display the art in the best way. Poor lighting tires people out and turns them off. The same is true when paintings cannot be hung in close proximity to each other.
3. Hanging times and security: When can you get in and hang the show? Where and when can people bring their art? When does the show have to come down? Can paintings be left overnight (or for several days)?
4. How are pictures to be displayed: Taping prints to the wall or putting in nails is usually not encouraged. Some places that have art shows regularly will have hooks already in place. A library in which I had a show furnished hooks which fit in a groove in the wall. Panels made of peg board work very well. An art group that is going to have regular shows will find it wise to invest in panels. Storage between shows presents some problems but if they can't all be stored in one place, farm them out two to a member and ask that they be put into garages. If display panels become scuffed or dirty, a fresh coat of paint should be applied. The important thing with panels or screens is that they should be secure. They should not be wobbly or easily knocked over. They need to have a firm base. Free standing panels (A) should have a wide base. Panels that hook together (B) help to brace each other but must be placed at angles (C). If you have the space, the sturdiest panels are those in the shape of an X (D).

A: SIDE VIEW
B
C: TOP VIEW
D: TOP VIEW

5. Refreshments: If you are planning on serving refreshments, is there a place to put them? Are the owners of the space willing to let you bring in food and drink? Some places will permit tea, coffee and soft drinks but nothing alcoholic.

Once you have artists lined up and have found a place, select a time. Timing is important. Find out when other events are being scheduled so you don't conflict with them. If the County Fair is being held in your town, it is a good time for an art show if you are in a building on the fairgrounds — but it is a bad time if you are in another part of town trying to compete with prize pickles and pigs.

Don't schedule an outdoor exhibit during the rainy season or when the wind blows the dust from one end of town to another.

You will need several committees to launch your show. If you have a small group, your committees may be composed of one or two people. Three committees are important to the success of a show: a hanging committee, a publicity committee and a refreshments committee.

Some words of consolation for the hanging committee: You won't be able to please everyone, so relax. No matter how hard the committee tries and how impartially it performs, it is a rare show that does not find at least one artist muttering, "Why is my picture hanging here and X's hanging over there?"

In addition, the hanging committee helps the juror, or jurors, if it is a juried show. This is a "fetch and carry" job as pictures are presented for approval or disapproval. In some cases, a juror will help hang a show, that is, tell a committee where to hang the pictures.

Having a juried show takes the burden of acceptance/rejection away from the local group. A juried show also implies a certain degree of competence and selection.

Jurors should not be connected with the sponsoring club or group nor should they be close relatives of exhibiting members. Compensation for jurors can range from money to a dinner with the club officers. Very often a small special exhibit of a juror's work is included in the show. In many localities, an artist or art teacher from a neighboring community will be glad to serve as juror. If the juror drives from another town, his or her gasoline should be paid.

Once the show is selected and hung, labels need to be made and put on the display. Labels should be typed or printed in very legible style. The following information should be included: artist's name, title of picture, medium and price. Items not for sale should be marked NFS.

A catalog is optional and can be as simple or as elaborate as you feel is affordable. A mimeographed list that duplicates the material on the labels will suffice or you can have a booklet that includes more

information about each artist and perhaps some photographs of works on display. Visitors enjoy receiving a list and the participating artists appreciate concrete evidence of their artistic endeavors.

Double check names, titles, etc. People tend to become very irritated (and rightfully so) over misspellings and incorrect information.

Publicity is one of the key factors in a successful art show. The object of such a show is to present the artists and their work to the public. However, to get the public to attend is a difficult task. Place posters in strategic places around town, send announcements to local radio and television stations. Contact your newspapers and try to get them to run a story. Ask them to cover the opening. In your budget, plan on one or two newspaper ads. Word of mouth also functions well — and involves telling the right people.

Refreshments should be simple: cookies, coffee, wine and tea are good choices. While refreshments help to make a relaxed, sociable atmosphere, remember that people are there to see the art and artists, not to have a full meal. Avoid having sticky or runny foods! Be sure there are handy places to dispose of used cups and napkins. Have paper towels available for the inevitable spills.

If smoking is permitted, be sure there are enough ash trays.

Invitations help get people to the show. They need not be elaborate but they should contain all the essential information: place, date, time. They can be run off at a quick-print shop at a nominal cost. Even the least expensive invitation looks classy when the design is good.

Encourage each artist to furnish a list of people to whom invitations should be sent. Lists should be coordinated to avoid duplicate mailings. Sometimes local businesses or individuals will act as patrons. This means a donation of money, services or goods. Patrons should be listed in the catalog and written thank you notes after the exhibit.

What about prizes? Prizes always add interest to a show. Winners should be selected by the juror or jurors. In the case of a non-juried show, prize winners should be selected by a person or persons not in the show. A follow-up story on the exhibit and a list of the prize winners can be sent to the newspapers in hopes of a feature. Naturally you are going to have a better chance of getting coverage in a small town than in a city where there are many organizations competing for publicity.

The other day, my friend Jane, who had been elected chairman of her exhibit committee phoned and said, "Our art club is having an exhibit. We are thinking of raising expense money by charging an entry fee but some of the members object. Someone has suggested that instead of a fee, we take a percentage of sales. We really don't know what to do." Since only club members were taking part in the exhibit, it did

not seem fair to charge an entry fee. Had the exhibit been open to non-members, an entry fee would have been reasonable. Usually members pay a reduced fee while non-members pay slightly more.

A percentage of sales is a good idea if you are reasonably sure you will have some sales. This is impossible to predict in advance because there are too many uncontrollable factors — from personal prejudices to world economic conditions.

Remember artists are disheartened and viewers discouraged by poorly hung, badly run exhibits. Organization and planning can make an exhibit memorable and often profitable.

Although we have been discussing group shows, the same suggestions apply to one-man shows. The main problem is that a lone venture does not have group support in terms of extra hands and dollars.

If you are ready for a show but don't want to go it alone, have a two or three person show. An exhibit such as that gives each artist more room than a group and a wider audience than a one-man effort. A good combination is to have two painters and a sculptor or potter.

As with the group show, be sure all details — financing, hanging and refreshments — are worked out in advance.

Exhibiting in a gallery involves other factors and is discussed in Chapter 15, For Better or Worse.

When you have reached a degree of professionalism, you may want to enter juried shows either in your area or other parts of the country. Most of these shows require submission of slides. In some cases there is a preliminary slide screening and the artists who survive this first round are asked to send their art work for final judging. Local shows are usually announced in the newspaper; regional and national ones are found in art magazines. The best information source is the monthly feature "Bulletin Board" in *American Artist*. Here you will find listed shows, requirements, dates of submission, entry fees, etc. Listings are arranged by state and city. Pay special attention to the requirements. Entering shows is a little like buying lottery tickets — you may win, you may lose. The attractive aspect of getting your work known and the possibility of sales and prizes may override the chance of rejection.

There is a natural corollary between painting pictures and showing them. Most artists want to show their work and some want to talk about what they have done. In general, artists are interested in sharing with others. I know I am. I enjoy painting but I also enjoy showing. In a way, it is the second part of the painting story and is no less an art form, if approached in the right way.

XIV

IF THE PRICE IS RIGHT

"I have no trouble thinking up subjects to paint but I'm not as sure when it comes to pricing and selling. Is there any easy formula?" asked Jane. "There is no easy formula," I told her. "If the work is good and if the price is right, you will probably have no trouble selling."

Determining that right price is essential, if sometimes difficult. Beginners often fall into one of two traps. They either place no value or too low a value on their work or, worse, they ask inflated prices that may strike the viewer as ridiculous. You can't start out asking thousands of dollars for your first work of art. True, pictures painted by movie stars, statesmen and other public figures command fabulous prices but you have to remember that people are not buying art as much as they are buying a piece of a celebrity.

Take a realistic approach when setting prices.

Prices are determined by demand and demand is created by your reputation. As in any other field, you have to establish a track record.

"I've spent so many hours on this painting, I'll never get enough money to pay for my time!" my friend said. Of course, you won't get back compensation in terms of the ordinary hour wage scale, at least when you are starting out. Only if you are doing a commercial piece of art such as a poster, can you charge by the hour.

My first pictures sold for $25, then $60 and gradually up the scale. I still remember the first picture I sold for $100. What a thrill it was. I had just had a new painting framed and was taking it home when an acquaintance stopped me on the street and admired the painting. When she asked the price, I hesitated — I wasn't in a hurry to sell it — and then said, "One hundred dollars!" "I'll take it," she said. And in a few minutes, she went on down the street with her new painting while I stood on the sidewalk dazed with a check for $100. I learned from that episode: take myself seriously and not sell myself too cheaply.

When you set prices, keep in mind you are charging for quality, reputation and demand. Obviously if your work is very popular, it will drive the prices up.

Location will affect prices: Art in cities is usually more expensive than art in small towns. And, if you have to pay a commission to a dealer, agent or gallery, it will mean a mark-up.

Like the chicken/egg question, which came first — prices or the

market? They are inseparable; you can't have one without the other.

In the beginning you will have to develop your own market. Although artists dislike selling, there is no way to avoid it. Later when you are better known, you may get an agent or have a gallery that handles your work. But for every artist handled by an agent or gallery, there are probably nine who continue to market their own work, either through choice or necessity.

Many artists sell from their homes or studios. One of the difficulties of this is that unless you live in an area zoned for business, you cannot put out a sign and you have to be reasonably discreet in your advertising. If you have good work, though, people will come to you. Check Chapter 12 for suggestions on how to publicize your art.

Selling from your home can be a low-key operation, but also very successful. One problem is to make sure visitors know which pictures are for sale. It looks tacky if you put price tags on pictures hanging on your own walls, yet you will find people are hesitant to ask about prices under these circumstances. One solution is to mention previous sales or make a semi-humorous remark about how your low overhead means lower prices, etc. If someone shows a special interest in a painting, talk about it; explain why you did what you did, when you did it, and so forth and then casually mention the price.

When your prices go up, you should be willing to sell on time payments. I have found that this is the only way some people can afford to buy art. Agree on a down payment and how the balance should be paid. I usually ask for one-third to one-half of the total price and the rest in monthly installments. For example, a $500 painting could have $200 or $250 down payment with monthly payments of $100 or $50 until the balance is paid. I let people take their pictures home while they are paying for them. This releases wall space and often buyers decide to get a second picture when they finish paying for the first.

As in any business, you have to use common sense when extending credit. If you don't know the individual or have doubts about the financial arrangement, keep the picture until the final payment is made.

If you have a separate studio or even a room in the house that is strictly studio you can always display your work there. Some clients seem more comfortable buying in that atmosphere. Don't overlook the possibility of selling what's on your easel. I have sold several paintings when they were still unfinished. In such cases, I always tell buyers that if they don't like the completed picture, they don't have to take it.

I no longer frame pictures while they are hanging in my studio. If a buyer wants me to have it framed, the cost is added to the price. I do mat drawings and works on paper and have them encased in protective

plastic. This costs about $10 a picture and is added to the price.

Occasionally you will have a person who buys a painting and wants it shipped. Bill them for packing, insurance and shipping costs. Just be sure they understand this is *not* included in the price of the painting.

There are ways to entice people to your home gallery. You can give a party when you have finished a particularly fine painting or a series of paintings or drawings. Also, let your friends know that they are welcome to bring their guests to see your work provided, of course, they make advance arrangements.

People love to visit an artist's studio, to see art being created and to get to talk to the artist. This often leads to sales.

Word-of-mouth is the best kind of advertising. Persons who have seen your work or are owners of it will talk up your art to others. In one instance, a woman who owned a painting brought her friend from out of town to see some of my new work. The visitor bought a painting. Later she wrote and asked for snapshots of others. She showed these to two of her friends and they also purchased paintings.

Get acquainted with local architects and interior decorators. Let them know what you have available. If their response is positive, you might want to make up a simple portfolio for them with slides or snapshots, information about yourself and your art. If an architect or designer is interested, discuss in advance all financial arrangements. Find out if you are going to deal directly with the client, if you set the prices and whether or not the designer gets a commission.

Many furniture stores carry paintings, usually reproductions. Some owners would be happy to display original art. Again, you should settle in advance any financial questions. You should also inquire as to who is responsible in case of damage, theft or other disaster.

As part of your selling technique, you should keep a list of persons who have bought your paintings. These people are always potential clients. When you have an exhibit, send them an invitation. As owners of your paintings, they like to have their good judgment reinforced by your continued success. One artist I know sends out a yearly holiday newsletter to all her customers. She combines greetings with an update on all her art activities.

As you become known as an artist, you may be commissioned to do pictures. When someone commissions a picture, it is wise to get all the details settled before you start work. Be sure that both of you understand what is to be done. Talk about size, content, framing, delivery date. A down payment is a good idea — usually upon acceptance of several rough sketches. There should be no surprises when working on commissions. If you aren't interested or feel you can't do what is

requested, say no. It is better to decline than to make yourself miserable trying to do something you either don't know how or don't really want to do.

Another possible source of income is through cards and prints. Here you have multiple copies of a painting to sell. You can also sell the painting itself, so it is a case of having your cake and eating it too.

You can try to sell your art to commercial art companies or to companies that specialize in making and selling prints. Get names and addresses from the current *Artists' Market* which can be found in most public libraries or bookstores. But selling is *not* easy — most firms have their own in-house artists or other artists under contract.

A second route is to print your own cards and prints. A good reproduction is not cheap and you will have to do your own advertising and distributing. But if you have a good subject, money and time to promote the finished product, you should be able to recoup your expenses and possibly make a profit.

Before you go into such a venture, do a market survey. Even if your family and friends are encouraging, remember they will account for only a small percentage of sales. Get printing quotes from several firms. Ask to see samples of their work. Read any contract carefully; if you have questions have a lawyer check it. If you are having cards printed, does that include envelopes? If you have to get your own envelopes, be sure your card is printed in a standard size so you can get readymade envelopes.

If you are going to sell by mail, you have to have shipping containers; tubes for prints and bags or boxes for cards. In addition to mail orders, try to sell your cards/prints wholesale to some retail outlets.

Unlike your paintings, prices are easier to determine for cards and prints because you have known costs. You need to add up the cost of printing, shipping, envelopes, color separations and include expenses of estimated advertising, storage charges or other related expenditures. Divide your total costs by the number of individual units printed and this will give you the cost of each card or print. Base your retail price on this cost and don't forget that wholesale prices to stores are 50% of the retail price.

On the positive side, cards and prints can result in extra money for you and possibly increased sales of your paintings. On the negative side, if you misjudge the sales potential of your product, you are going to lose money and may end up with a garage full of unsold merchandise. Keep a realistic perspective on what is possible. It is better to reproduce 300 copies of an image and sell 295 of them than to print 3,000 and sell 295!

XV

FOR BETTER OR WORSE

Saying "I do" to a gallery means you are making a commitment. No one asks, "Do you take this gallery for better or worse"...but the implication is there. There is a legal contract and mutual obligation and the artist-gallery relationship *is* a marriage of trust, patience and understanding on both sides to make it a successful partnership. The same applies to an artist-agent relationship.

Galleries first: Having a one-person or group show in a gallery does a lot for an artist's ego and prestige. It is a stamp of approval...that is, if the gallery is an honest one. Avoid galleries that offer you a show of your work *if* you foot the entire bill for expenses — including rent during the time your show is up. In this case, the gallery is not interested in the quality of your work, the future of your career or promoting your art, but only in your ability to pay.

A gallery may ask you to share some of the costs of refreshments or advertising, but these are minor compared to the overall investment. One gallery I know charges its artists a small amount to be used for advertising. The result is more extensive advertising than the gallery alone could afford. Both sides benefit from this sharing of the burden.

As a rule, you have to go out and find a gallery. Occasionally, it works the other way, a gallery contacts you. It may be that someone at the gallery has seen your work or that your name has been suggested to them. But don't sit around waiting for a gallery to contact you! When you feel you are ready, start your campaign.

You will need a portfolio of your work. Color slides are best but if you have some photographs include them. Have a descriptive sheet about your art activities. If you have sold paintings to museums, corporations or important collectors, include those names. List all exhibits you have been in and any prizes you have won. Give your academic history if it is pertinent.

Before you contact a gallery, read all you can about it. Ask yourself if this is the right place for your art. If a gallery advertises that its specialty is Western art and you paint seascapes, the obvious answer is to skip that gallery. If you paint abstractions, the gallery that shows only representational art will not be interested in your portfolio.

When sending your portfolio by mail, always include a self-addressed stamped return envelope. The envelope should be of the

correct size to hold the materials you want returned.

The letter you enclose should be brief and to the point. Don't put in unnecessary information. If the gallery is within driving distance, indicate that you would like to make an appointment to show your work — at their convenience.

Here is a sample letter:

> 232 Breckinridge Road
> Santa Fe, NM 87501
> September 29, 1982

Felix Bennett
Bennett Gallery
29 Solar Circle
Albuquerque, NM 87103

Dear Mr. Bennett:
 Enclosed are slides and photographs of paintings I have completed in the past three years.

 In July I received the Vera Fisher Prize for oil painting at the Henderson Heights Art Fair in Baltimore.

 Two of my paintings have been purchased by the Reubenbarrow Corporation: one in 1979 and one in 1981.

 I do not presently have a gallery affiliation.

 After you have reviewed my portfolio, I would be pleased to meet with you for you to see some of the paintings. I am free any day after 3 p.m. and all day Saturday. I can be reached by telephone at 991-1199 after 3:30 p.m.

 Thank you for considering my work.

Sincerely,

Tom Smith

Contact local galleries by phone and ask for an appointment or follow the same procedure as with out-of-town galleries. I personally prefer to use the mail. It is easier for people to say no over the phone because they may be busy and you are only a voice. Usually, if only out of curiosity, they will look at something received in the mail.

Don't be discouraged if they say they already have all the artists they can take. Good galleries have a limit on how many artists they can promote. If a gallery likes your work but is full, they may suggest another place. When you contact that other gallery, be sure and mention that the "X Gallery" suggested their name to you.

If a gallery asks you to bring samples of your work, take a limited

number — only the best examples. If they ask for a specific number, take exactly that many. Don't spend the time telling the gallery owner or manager how wonderful you are. Let your work speak for itself.

If the gallery shows interest, they may suggest ways in which you can work with them. At first, you may be asked to leave work on consignment. Consignment means that your work will be displayed and the gallery will make an effort to sell it. As pictures are sold, you will get your money, less the commission the gallery charges (usually 40%). Before you leave your pictures, get a written receipt for them and a statement of terms. It is prudent for both sides that there be a time limit, a careful spelling out of percentages, insurance coverage and other matters. The gallery will tell you when and how they want paintings.

Your objective is to have a permanent contract with a gallery. This means that you will have examples of your work on continuous display, that the gallery will provide publicity and promote your work. Usually there are to be one-man shows at stated intervals. Again, the financial and other business details should be clearly understood by both parties. Don't be shocked if the gallery asks for a commission of 50% as that has become standard in many galleries. Remember that for their share, the gallery is providing you with salesroom and sales force. If they advertise in regional and national publications, this is another item you probably could not afford as an individual.

There is another kind of gallery — a cooperative run by the artists themselves. Membership is limited and expenses and responsibilities of running the gallery shared. If there is already such a gallery in existence in your town and you have the time to participate see about their membership requirements. Sometimes the whole group has to vote on a newcomer; sometimes there is a selection committee. If you apply and are accepted, find out how the expenses are prorated and how many hours a week or month you are expected to work.

Agents: Do you need an agent? A professional artist certainly benefits from having an agent just as a professional actor or writer needs one. You can sell your own art *if* — you have the time and the knack of salesmanship. Acting as your own agent has two advantages: You have only one artist, yourself, to promote and you do not have to pay a commission to anyone else.

On the other hand, the advantages of having an agent work for you are many. An agent has time to promote you and is hopefully able to make you known beyond your local area. An agent, if already established, has a list of potential buyers and access to corporations, foundations and publications.

Yes, with an agent, you will pay — but you will have more time to

paint. You will not have to worry about business details. A good agent earns his or her commission because he is doing things for you that you couldn't do without giving up painting time. Some gallery owners also act as agents. It is a nice dual role for, in addition to showing your work in their gallery, they can arrange shows in other locations.

An agent, like a gallery, is something you work toward. An agent is going to be interested in three things: saleability, productivity and reliability. An agent is in business to sell and unless there is some financial return along with a steady flow of work from you, delivered on time, you will find the relationship difficult to maintain.

An agent or a gallery often asks for the right of first refusal. This simply means that you show each new piece of work to them first so they can say yes or no to it. If the answer is yes, the work becomes part of your agreement with them. If they say no, it remains yours and you can do what you want with it. You can sell it yourself and you do not have to pay a commission on that sale. However, it is rare that any work will get a negative response if you keep your usual high standards.

My agent/gallery owner lives several states away so I send her snapshots of completed paintings. When she says yes, I ship the painting to her. It is handy to have a gallery within driving distance but if you don't, you have to add packing and shipping to your expenses. I now use a professional packer who makes crates and takes care of shipping. Several years ago, I was fortunate enough to have a retired neighbor who was a skilled handyman and he did all my packing for a moderate fee.

Paintings can be sent UPS, Greyhound, U.S. mail or truck. Your choice is usually determined by size, destination and preference of receiver.

As a rule, the artist pays the cost of shipping to a gallery and, if paintings are returned, the gallery will usually pay. However, if you request the return, they will probably be sent collect. Financial arrangements about shipping can be spelled out in your contract.

All shipments, no matter which carrier is used, should be fully insured. The gallery will tell you whether they want pictures shipped unframed or framed. Some galleries prefer to do their own framing. The cost of the frame is either added to the cost of the picture or deducted from the artist's share. I have found that gallery owners frame my pictures better than I do so I am happy to leave it to them.

Don't undersell your gallery or agent. Naturally, if people find that they can buy pictures cheaper from you, they will not go to the gallery. You should always work *with* your gallery or agent, not against them.

Incidentally, don't overlook the beginning agent or the new gallery.

They may have less experience but they are usually aggressive and eager to succeed. It may be a break for you especially if they go on to become a major force in the art world.

XVI
SATISFYING YOUR EGO & THE I.R.S.

It is important to keep records. You should keep records of the paintings you do, the sales you make and your art-related expenses. Some of this information can be used to bolster your ego and some of it will make the IRS happy.

When you first start painting, you think you will remember every picture you paint and all the information about it. After a few years, you are like the old woman in a shoe — you have too many and you can't tell Tom from Jerry! So start out by keeping records from that very first picture or drawing.

Here are some of the facts you should record:

Title / Size / Medium
Completion Date / Exhibition Record / Sales Record

LANCASTER BRIDGE
acrylic on canvas, 18 x 24
March 10, 1981
Twin Cities Art Club Exhibit at the
Oak View Country Club, April 1 - 15, 1981
Sold to: Mr. & Mrs. Leo Finer
2217 Manquette Parkway
Minneapolis, MI 55440

Size is always given according to the way the picture is painted. A long narrow canvas (A) with a picture that is painted vertically is listed as 20" x 10"; but if the same canvas (B) is a horizontal painting it is listed as 10" x 20". Some people give sizes in centimeters but I admit that I still use inches as more people seem to be able to understand and relate to that measurement. If you are doing very large canvases, several feet in length and width, you give the size in feet.

You can add prices to these records or keep a separate price list and list of sales. A very valuable part of the record is a color snapshot of each work. This snapshot should be pasted or taped to the bottom of your page of information.

I keep my records in 6" x 9" blank books; Jane T keeps her records on 5" x 8" file cards. Which is best? Although basically it depends upon individual preference, there are pros and cons for each system.

The books are easily taken with you if you want to show interested persons what you have done or what is available. Books afford you a chronological view of your work and progress. When you finish a book, it is helpful to make an alphabetical list of the titles and paste it in the front or back of the book. Each page in your book should be numbered thus providing a handy way to locate each title.

Lancaster Bridge	151
Lincoln Towers	109
Mesa Verde View	162
Miner's Portrait	160
New Town	82

After several years you may have a number of volumes and these are then not so easy to carry around. However, I have found that usually you are only working with your current book.

A card file should contain the same information as listed for the books. The snapshot can be pasted on the bottom of the card or on the back. With a card file, you can pull out only the records of the paintings you want when someone asks for examples of your work. But it is not as easy to take a file along if you need your complete list. Also, since it is best to arrange the cards alphabetically by title, you have to take out the cards and rearrange them to make a chronological list. Jane T. has made that easier for herself by color-coding each year with a slash of color across the upper left hand corner of the card.

Although it is unlikely that you will forget which pictures you have sold, there is a definite psychological advantage in having a special mark or notation for SOLD items. We all remember early school days when getting a star was a sign of achievement. Give yourself stars or something similar for sales. I use brightly color dots in my book to indicate sales. I put them in the upper corner of the page. Jane T uses red metallic stars. She gets them at the dime store.

"When sales are slow or it is a down period, I just look at those stars and my ego gets a boost," Jane explained.

You will need to keep accurate financial records. This is absolutely

necessary when you pass from amateur to professional. Once you start selling, you must keep track of when and how much. It is part of your reportable income.

On the one hand you are going to report income, on the other hand you are going to report expenses. Keep an account of supplies, shipping costs, long distance calls, travel and other expenses related to your art. You should get receipts unless you pay by check. Keep this information up to date. I use a loose-leaf notebook with a separate sheet for each supplier. When I pay by check, I indicate the number of the check. With this system I can quickly locate any transaction.

I also keep an on-going record of sales with notations of when paid, how paid (check or cash) and name of the payer and the title of the piece of art purchased.

DIAMOND ART SUPPLY, INC.

date	for	check #	paid	owe	balance
3.10	brushes			2.98	2.98
3.15	canvas			17.00	19.98
4.04		293	19.98		- 0 -
4.15	book	VISA	15.95	15.95	- 0 -
4.25	canvas			35.00	35.00

date	from	for	by	amt rec
3.14	Mrs. Jack Elderhof	*Blue Flowers*	cash	$ 35.00
4.02	Worth's Gallery	*Night Scene*	check	$150.00
4.08	William Rexford	*Train Depot*	check	$250.00

With this system, you also know at a glance what your current financial status is. Should you buy that art book today or wait until next month? Since it may be more convenient to have a charge account at your art supply store, it will give you a current balance on that account.

At the end of the year you will use these records to prepare your income tax forms. If you are a professional artist, certain expenses are deductible. I'm an artist, not a financial wizard, so I have found it pays to have an expert do my taxes. I do save money in tax preparation fees by having my records organized before I go for an appointment. This is easy because I keep my records up all year. It is very hard to remember in January what happened in June!

Above all, don't brag to your family or friends that last year you sold $3,000 worth of art and then put on your tax return $500. This information does get around. If your conscience doesn't keep you awake, inquiry and action by the IRS will!

If you send out slides or snapshots to potential customers or galleries, keep a record of what you sent and when. If you have quoted prices, make a note of them. Not everyone replies at once and it would be embarrassing to get a letter after several weeks and not be able to remember the exact price you quoted in your letter.

Keep a file of your art correspondence, receipts and related materials. Another project I like to recommend is an art journal or diary. The entries can be as short or as lengthy as you have time and words to spare. An art journal is a kind of intimate friend to whom you can confide your thoughts (and sometimes doubts) about your art. You can record your aspirations, hopes, difficulties and your triumphs. You can note when you started a certain picture and chronicle your progress with it. A journal is also useful for making notes about galleries and museums that you visit and what you saw and what you thought about what you saw. It is also the place to record art books you have read and don't want to forget. You may want to add your comments about the books.

None of these suggestions will guarantee your artistic success... but they will help make your life easier!

XVII
MAKING IT LEGALLY YOURS

On January 1, 1978 the new copyright law of the United States became effective. Although copyright registration is voluntary, it is the only way to protect certain rights.

The duration of copyright is for the lifetime of the artist/author plus 50 years. Works that were created before that time but not copyrighted can be copyrighted under the new law provided they have not gone into public domain.

Copyright for works of art comes under Class VI: Works of the Visual Arts. This includes both two and three dimensional works. Fine and graphic art (as well as prints and art reproductions) are among the works in this category. It includes published and unpublished works in the visual art field. Basically it can be said to include "all works of artistic craftsmanship."

When writing for an application form, you ask for form VA. You get application forms from:

 COPYRIGHT OFFICE
 LIBRARY OF CONGRESS
 Washington, D.C. 20559

When you get your form, fill it in with ink or by typewriter. Print the information if you do it by hand. The registration fee is $10. This should be in the form of a check, money order or bank draft. If you are doing this frequently, you may want to open a deposit account with the Copyright Office. Send all your material together: the application form, the fee and the deposit. Now, obviously in works of art, you cannot deposit your one and only original work, so you send a photograph of the work.

You must also put a copyright notice on your work. This can go on the front or back. Since most artists sign and date paintings anyway, it merely means adding a © so that the signature would read:

 © John Jones 1982

The law simply requires that the notice appear in a "reasonable" place on the work. If you have done a series of related drawings or illustrations, you can register them as a group, paying only *one fee.*

The use of photographs is also permitted when there have been less than five copies made or published or when an edition of no more than 300 numbered copies have been offered for sale.

The date of copyright is the date the material is received in the

Copyright Office.

You will get back a certificate of copyright. This is a photocoy of the application on the certificate form and will have the signature of the Register and the official seal. Each copyright has its own registration number.

If one of your drawings is published in a newspaper, you would register it in Class VA; not as Class TX. The correct registration is dependent upon the kind of contribution, not where it appears.

Copyright establishes your *ownership rights.* You can sell a picture but retain the copyright. Ownership of the copyright means you have the *exclusive* right to reproduce your work — on cards or posters, for example. If other people want to reproduce your work, they have to get your permission and pay the fee you ask. If you have the copyright and someone uses your work without permission, you can sue for damages and prevent them from continuing to use your work.

You can add a provision to sales contracts which states, "All reproduction rights are reserved to the artist."

Rights can be assigned in various ways. Exclusive rights gives the other person or company the right to be the only one using your work. Exclusive rights can be further defined and regulated by specifying exclusive rights in a certain areas (North America), a period of time (one year) or a type of medium (all woodcuts produced). Exclusive rights must be written and signed by both parties. *Nonexclusive rights* can be transferred verbally.

This is only a brief survey of copyright. Your local public library will have more material on the subject. The Copyright Office will send you informational circulars; they will *not* give legal advice or opinions. If you have a legal question, you should consult a lawyer.

XVIII

TEN TIMELY TIPS

If you have bifocals or trifocals as I do, you may find it difficult to paint with them on but, obviously, you aren't going to be able to do much without them. I solved this by having a pair of glasses made with just the lower part of my lens (half-glasses) in them, so that I can still see to get around the studio. These enable me to do my close work without strain and without bobbing my head around to get the right focus.

For paint caps that stick or for artists whose strength is in their thoughts and not their hands, a pair of small pliers is indispensable. Like a cook who can't prepare a meal if a particular implement is lost or broken, I always say I wouldn't be able to paint without my pliers!

When I am not sure how colors are going to look when mixed together, I use my "testing board." This is a canvas board, 8 x 10 or 9 x 12, on which I can paint small swatches and then check the results. It is also good for checking the effectiveness of one color overpainted on another. It is easier to do this on the testing board than to muddle things up on your painting.

To control the amount of water added to your paint, especially when you want to add only a small amount, use a medicine dropper (eye dropper). You can get one at any drug store.

When I start work on a new picture, I also start a "work sheet." On this sheet I list the colors I am using and for which parts of the painting. This is especially useful if you have to go back and touch up or if there are several days' interval between painting sessions. I also indicate roughly the amounts of colors used in mixtures.

THE ZOO
 Sky = Blue val.5
 Sidewalk = Gray (White 4 + Black 1)
 Wall = Yellow Oxide 2 + White 1; black mortar lines
 Grass = Light Green Oxide

In between painting times, keep your painting where you can look at it. I reserve one wall in my bedroom for my current work-in-progress. I take it in there when my painting time is over and spend some time studying it before I go to sleep and also when I wake up in the morning. Removed from the close proximity of the easel, I get a new perspective. Sometimes I see things that need changing, most times I see things that please me, and many times I have solved painting problems that bothered me.

Customize your paintings. Everybody likes to feel that they are special and that something unique belongs to them. On commissioned paintings where it is appropriate I have used clients' names or initials if they wished it done. One man ordered a factory scene with his name on the water tower of the building. I have also used birth and other commemorative dates when requested. Another man had his birth date put on a box car in a railroad painting; another individual had her family name on a moving van.

Work from the center of your palette to the edges. This will keep you from getting your sleeve or the palm of your hand in wet paint.

You might want to keep your first picture. As you continue to paint and learn more about art, you will notice a dramatic improvement in your work. If ever you feel discouraged, get out that first picture and hold it up to your most recent one — and pat yourself on the back!

Always write down your ideas for pictures. It's so easy to forget ideas in the press of everyday life and work. When you are ready to start a new painting or drawing, look at your list and see if any particular idea appeals to you. It is also good to keep a list of names of streets, towns and shops that you might want to use someday.

XIX

TERMS TO TOSS AROUND

Being an artist means knowing the meaning of some of the art terms. The word "charcoal" shouldn't any longer just mean "barbecue" when you hear it. You need to know that "impasto" is not an Italian culinary delight and that you don't chew "art gum" in the studio. So here are some terms to toss around...

Abstract art - Non-figurative art, usually shapes or forms that are not realistic.

Acrylics - Water-based plastic paints. They are very versatile, can be used thinly as regular watercolors or thickly like oils.

Art gum - Non-abrasive, rubber eraser.

Charcoal - Available in the form of sticks or compressed in pencil form and encased in wood or paper wrapper. Used for sketching.

Chroma - The brilliance or intensity of a color.

Cold pressed - Drawing paper with a medium rough surface. Suitable for pencil, charcoal, ink and watercolor.

Conte crayons - Compressed pigment and available in sticks and pencils. Comes in red, brown, black and white. Used in drawing.

Cool colors - Green and blue.

Dry brush - Using a brush with very dry color. When used on a wet surface, it gives a textured effect. Often used in overpainting one color on another.

Fixative - A commercial spray for charcoal, pencil or pastel drawings; keeps them from smudging.

Gesso - White pigment with a binder used as a ground for painting. Available in liquid or dry to be mixed as directed.

Glaze - A transparent color painted over a dry underpainting.

Gouache - Opaque watercolor. In gouache, white is used as a pigment.

Ground - The surface on which a painting or drawing is made: canvas, paper, and so forth.

Highlight - That portion of a surface which catches the most light.

Hot pressed - Drawing paper with a very smooth surface.

Hue - Another word for color.

Illustration board - Drawing paper mounted on a rigid board. Used for pencil, ink, watercolor. Comes in various textures.

Impasto - Thick application of paint. Impasto is often done with a palette knife.

India ink - Black drawing ink.

Medium - The material used in making a picture: oils, acrylics, watercolors, pen and ink, etc. Also refers to the substance in which pigments are ground to make paint.

Oils - Pigments ground in linseed or poppy oil.

Palette - A surface on which paints are mixed; can be paper, metal, plastic or glass.

Palette knife - A spatula used for blending paints and for painting. Comes in various shapes, some with pointed ends, some with square and some with rounded ends.

Pastels - Dry pigments in stick form.

Scumble - An opaque color painted over an underpainting. Often used to lighten a dark color.

Sketch box - A box of wood or metal used for carrying art supplies.

Turpentine - Used for thinning oils and for cleaning brushes used for oil painting. Use distilled turpentine.

Underpainting - Preliminary painting done as a guide for later applications of glazes or other paint.

Value - Degree of lightness or darkness of a color.

Warm colors - Red and yellow.

Wash - Thin, diluted color. Often used in underpainting.

Watercolor block - Watercolor paper in a pad. Bound on four sides, each sheet must be removed by a knife. Used on the block it is very stable and useful for the traveller or outdoor painter.

Watercolors - Transparent colors applied to paper. White paint is not used, the white comes from the paper.

BIBLIOGRAPHY

BOOKS

Artist's Market. Cincinnati, OH: Writer's Digest Books. Appears annually. Illustrated. Although this is more for the commercial artist, there are sections that will interest any artist who wants to sell work. There are some practical helps in the front of each volume. There are sections on how to sell to the greeting card market, magazine illustrations, etc.

Baigell, Matthew. *Dictionary of American Art.* New York: Harper & Row, 1979, 390 pp. $7.95. From the 16th century to the present. Over 650 entries, mostly to people.

Caplin, Lee Evan, ed. *The Business of Art.* Englewood Cliffs, NJ: Prentice Hall, 1982, 383 pp. Illustrated. $9.95. Includes index. Published in cooperation with the National Endowment for the Arts. All about the business end including information on estate and gift tax planning; craft fairs, galleries, etc. Also has a section on the art scene in some of the larger cities such as New York, Los Angeles and Chicago.

Encyclopedia of American Art. New York: Dutton, 1981. 669 pp. Illustrated. $39.95. Includes bibliography. Arranged A - Z with more than 1,100 entries.

Gombrich, Ernest H. *The Story of Art.* Oxford: Phaidon, 1972. 506 pp. Illustrated. $12.95. Includes chronological charts and an index.

Hatton, Richard G. *Figure Drawing.* New York: Dover, 1965. 350 pp. Illustrated. $4.50. Includes index. Although this was originally published in 1904, it is still an excellent book for figure drawing. Has over 300 illustrations.

Hill, Tom. *Color for the Watercolor Painter.* New York: Watson-Guptill, 1982. 159 pp. Illustrated. $22.50. Includes index and bibliography. A good, basic book on materials, tools and techniques.

McCann, Michael. *Health Hazards Manual for Artists.* New York: Foundation for the Community of Artists, 1981. 36 pp. Very practical and includes index and bibliography.

Murray, Peter and Linda. *The Penguin Dictionary of Art and Artists*. Harmondsworth, Eng: Penguin Books, 1976. 493 pp. $4.95 (4th ed.). Has short biographies of over 1,000 artists, also information about artistic terms, periods, etc.

Nicolaides, Kimon. *The Natural Way to Draw. A Working Plan for Art Study*. Boston: Houghton Mifflin, 1969. 221 pp. Illustrated. $6.95. Excellent exercises, art philosophy and technique development.

Shook, George, and Witt, Gary. *Sharp Focus Watercolor Painting; Techniques for Hot-Pressed Surfaces*. New York: Watson-Guptill, 1981. 143 pp. Illustrated. $21.95. Includes index. Very helpful, lots of instruction on technique.

A Visual Dictionary of Art. Greenwich, CT: New York Graphic Society, 1974. 640 pp. Illustrated. $14.95. Includes index and bibliography. More than 4,500 entries: artists, techniques and art-related material.

PERIODICALS

American Artist. The most practical national art magazine, published monthly. Each issue has several articles on American artists with down-to-earth discussions of their work. There is a technical question and answer page in each issue. Information is given on coming exhibitions and competitions that artists can enter. There are reviews of art books. The advertising concentrates on products, equipment and educational services.

Art in America. A glossy, sophisticated magazine. Includes reviews of exhibitions, serious articles and world art news. Lots of advertisements for galleries and exhibitions.

Art In America Annual Guide to Galleries, Museums, Artists.
This serves as an index to *Art In America* plus being a fairly complete guide to galleries, museums, artists and gallery directors. It is arranged by state, then city. There are several indexes so it is easy to locate places and people. It reviews the past year's activities and special events. Has advertisements for galleries and services.

Art News. Each issue has many articles on contemporary artists as well as famous artists of the past. Lives, philosophies and techniques discussed. Most issues have articles on well-known art collections and their specialties or on American museums and their collections. Book reviews and news of the national and international art scene. Gallery advertising.

LIST OF ASSOCIATIONS

There are associations on all levels from national to local. Some associations limit their membership to residents of a particular area while others welcome members from throughout the country. The criteria for membership may range from "by invitation only" to an interest and support of the arts. The list below is only a sampling of what exists. I encourage you to see what is available in your area.

Allied Artists of America
145 Lexington Ave.
New York, NY 10010

American Abstract Artists
c/o Irene Rousseau
41 Sunset Drive
Summit, NJ 07901

American Artists Professional League
215 Park Avenue South
New York, NY 10003

American Ass'n of Creative Artists
P.O. Box 50392
Chicago, IL 60650

American Council for the Arts
570 7th Avenue
New York, NY 10018

American Federation of the Arts
41 East 65th Street
New York, NY 10021

American Society of Artists
1297 Merchandise Mart Plaza
Chicago, IL 60654

American Watercolor Society
14 East 90th St.
New York, NY 10028

Art Information Center
189 Lexington Ave.
New York, NY 10016

Artists Equity Association
3726 Albemarle St. NW
Washington, D.C. 20016

Ass'n of Artist-Run Galleries
152 Wooster St.
New York, NY 10012

Baltimore Watercolor Society
600 Oak Hill Road
Catonsville, MD 21228

Center for Arts Information
625 Broadway
New York, NY 10012

Drawing Center
137 Greene Street
New York, NY 10012

Foundation for the Advancement
of Artists
1315 Walnut St., Bldg
Philadelphia, PA 19107

Georgia Watercolor Society
P.O. Box 2411
Columbus, GA 31902

Gold Goast Watercolor Society
P.O. Box 24395
Fort Lauderdale, FL 33307

Golden West Watercolor Society
P.O. Box 67345
Los Angeles, CA 90067

Illinois Watercolor Society
P.O. Box 482
Glenview, IL 60025

Kentucky Watercolor society
P.O. Box 7125
Louisville, KY 40207

Midwest Watercolor Society
111 West Washington Blvd.
Lombard, IL 60148

Miniature Art Society of Florida
c/o YWCA
222 S. Lincoln Avenue
Clearwater, FL 33516

Miniature Art Society of New Jersey
c/o Pat Longley
58 Elm Street
Florham Park, NJ 07932

National Ass'n of Women Artists
41 Union Square West
New York, NY 10003

National Watercolor Society
c/o Katherine Page Porter
7242 Fountain Ave.
Los Angeles, CA 90046

New England Watercolor Society
10 Monumental Hill Road
Chelmsford, MA 01824

Northwest Watercolor Society
420 10th Ave.
Kirkland, WA 98033

Northstar Watercolor Society
c/o Judith R. Blain
2193 Deer Pass Trail
White Bear Lake, MN 55110

Pennsylvania Society of Watercolor
Painters
P.O. Box 3772
Harrisburg, PA 17105

San Antonio Watercolor Group
3207 Canaveral
San Antonio, TX 78217

San Diego Watercolor Society
P.O. Box 550
Coronado, CA 92118

Society of Watercolor Artists
c/o Irene Davis
34 Caddo Peak
Joshua, TX 76058

Southern Watercolor Society
413 Andrew Jackson Trail
Gulf Breeze, FL 32561

Southwestern Watercolor Society
c/o Anita Meynig
6335 Brookshire Drive
Dallas, TX 75230

Watercolor Art Society - Houston
1738 Sunset Blvd.
Houston, TX 77005

Watercolor Society of Alabama
P.O. Box 43011
Birmingham, AL 35243

Watercolor Society of North Carolina
522 Willoughby St., Apt. 4
Charlotte, NC 28207

Watercolor West
P.O. Box 213
Redlands, CA 92373

For information on grants, fellowships and related matters, contact your state Commission on the Arts or the

National Endowment for the Arts
2401 E Street N.W.
Washington, D.C. 20506

AFTERWORD

I hope that if you had never tried art before, that you did so while you were reading this book. And, if you were already working in some kind of art, I hope that the book gave you encouragement and perhaps, some new ideas. Art is fun — so make it and keep it an enjoyable experience. The best closing words I can think of are not mine but those of Henry Miller, who wrote,

To paint is to love again,
and to love is to live to the fullest.

INDEX

Acrylic Painting 18-22, 66
Advertising 44-45
Agents 57-58
Art Club 39-41
Associations 72-74
Bookkeeping 62
Books 31, 70-71
Cards 54
Classes and Art Education 36-38
Color Mixing 20-21, 66
Copyright 64-65
Drawing and Sketching 14-17
Equipment 8, 10-13, 18-19, 66
Exhibiting 42, 46-50
Galleries 55-59
Glossary 68-69
Idea File 27-31
Oil Painting 18-22
Photography 32-35
Prices 51
Prints 54
Records 60-63, 66
Selling 52-54
Studios 6-9
Subjects 25-26
Supplies 18-19
Technique 14-24, 66-67
Watercolor 23-24

www.ingramcontent.com/pod-product-compliance
Lightning Source LLC
Chambersburg PA
CBHW020930180526
45163CB00007B/2966